IMAGES
of America

WILLMAR

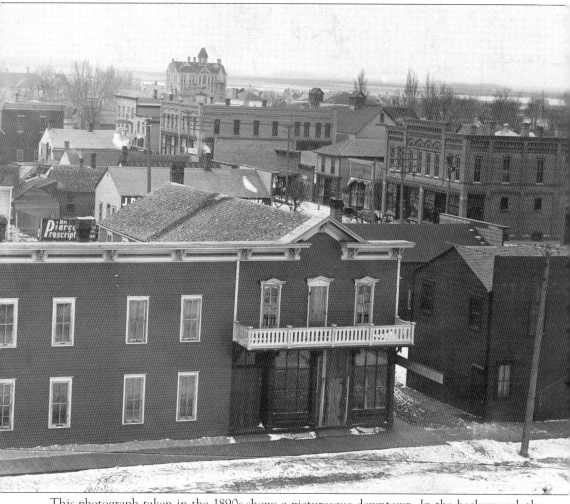

This photograph taken in the 1890s shows a picturesque downtown. In the background, the Willmar High School stands stoically alone, the only break in the vast prairie spanning the horizon. While many of these buildings are gone today, they portray a budding new city filled with promise. (Courtesy of the Kandiyohi County Historical Society.)

ON THE COVER: This 1960s view looking west down Litchfield Avenue shows the heart of mid-century downtown Willmar. Classic automobiles cruise down the boulevard, passing by the neon storefronts of many warmly remembered enterprises. Pictured in this sunny summer scene are Hedlund Drug, the Puritan Café, Hogan's, First National Bank, and several other businesses. (Courtesy of the Kandiyohi County Historical Society.)

IMAGES
of America

WILLMAR

Jason Grabinger

ARCADIA
PUBLISHING

Published by Arcadia Publishing
Charleston, South Carolina

Printed in the United States of America

Library of Congress Control Number: 2018932491

For all general information, please contact Arcadia Publishing:
Telephone 843-853-2070
Fax 843-853-0044
E-mail sales@arcadiapublishing.com
For customer service and orders:
Toll-Free 1-888-313-2665

Visit us on the Internet at www.arcadiapublishing.com

To Candace, thank you for believing in me.
To mom and dad, thank you for instilling in
me the passion to follow my dreams.
To the people of Willmar, thank you for taking
in our ragtag group with open arms.

CONTENTS

ACKNOWLEDGMENTS

This book was made possible thanks to the amazing staff at the Kandiyohi County Historical Society. I am greatly indebted to executive director Jill Wohnoutka and collections assistant Bob Larson. From the earliest stages of the process, their level of interest, assistance, and work to make this happen was incredible. The rest of the staff, board of directors, and countless volunteers who have given so much of their time and talent to create such a wonderful resource for local history buffs like myself are simply astounding. The professionalism and passion that I was privileged to experience at the museum and research library is in my opinion as good or better than any other county historical society I have ever had experience with.

Unless otherwise noted, all images contained in this book were provided by the Kandiyohi County Historical Society.

I also owe a debt of gratitude to Arcadia Publishing and publisher Jeff Ruetsche for accepting my proposal and making a lifelong dream of publishing a historical work come true. To my editor, Stacia Bannerman, I genuinely appreciate the work and expertise you provided. I have long been an avid reader of the Images of America series and could not be prouder and also grateful for the opportunity to be a part of it myself.

For me, writing is a passion that I consider a privilege and am always eager to do. However, writing a book also affects the friends and family who may sometimes be required to sacrifice in order to allow me the opportunity. To my wife, Candace, thank you sincerely for your willingness to share me with my research and writing. Without your help and encouragement, this book would not be possible. Nor would it be nearly as meaningful even if it were. To my children, who sometimes had to leave daddy alone so he could work on the computer, you are my world. I also would like to thank my parents for teaching me to read, encouraging me every step of the way, and simply loving me always, even when I was (and still am) unlovable.

Lastly, the people of Willmar deserve special acknowledgment. Without you, there would be no history to write. Being a transplant here has been an absolute joy, and I am proud to now be counted among you.

INTRODUCTION

The challenge in attempting to tell the history of a community is in finding the words and images that best tell its overall story. As individuals, we each have countless anecdotes, events, emotions, and other experiences that make an absolute and final volume about our lives impossible to be fully completed. Instead, the goal must be to touch upon small moments that best represent the whole of our lives. When telling the history of a community, which is made up of thousands of individuals, the challenge becomes even more complex.

Decade after decade, communities are in a constant state of change. As each new generation goes forth and makes its mark on one another, the land, the streets, the buildings, the events, and all the other aspects that make up a city, new stories always need to be told. In the following pages, my goal has been to give but a small glimpse into the history of Willmar, Minnesota. As you browse through the images and the small descriptions under each photograph, it is valuable to remember that this body of work is not by any means comprehensive. Instead, my goal in compiling this work was to create a brief and interesting narrative, telling an overall story yet also telling an individual story of each moment in time captured by the camera lens.

History has great power. It allows us to reminisce about the moments and eras in our lives that mean something to us. It provides a way to feel emotion. Through history, we are able to rejoice in our successes, learn from our mistakes, pass on a legacy, grow as a people, and move forward with a strong foundation. History greatly enriches our lives.

Photographs contained within this volume are not always picture perfect. Some may be a bit overexposed, others underexposed. Certain shots may be a bit out of focus. Others may be cut off at a spot that makes us long to see what lies just beyond. The same is true about life. Moments experienced are not always perfect either. I am of the opinion that it is in the imperfections where the most beautiful of experiences reside. Joys and sorrows, challenges we must fight to overcome, and experiences we wish would have lasted just a bit longer are the moments that most etch themselves in our memories. Imperfections make the moments no less important and no less valuable—perhaps the contrary. They are real. We can stand firm upon them. They are life.

Willmar is not just an All-America City because it received this honored designation from the National Civic League in 2005. It is truly a wonderful place to live, work, and raise a family. A diverse and growing community, Willmar is home to a thriving economy, great schools, and amenities often only seen in larger cities. Among all this, Willmar's residents are friendly and accepting with a rich historical tradition. Originally founded as a railroad town, Willmar is located in west central Minnesota, just 95 miles from Minneapolis and St. Paul. As the county seat for Kandiyohi, it is the hub of the region. The estimated population is 19,570 individuals who enjoy beautiful lakes, numerous well-kept parks, and safe streets.

The area of land and water today known as Willmar was first inhabited by the Dakota or Sioux Indians. Having been pushed south from the Great Lakes by the Ojibway, the Dakota settled here among the lakes and prairies. A man named Jacob Fahlstrom is the first known white man to visit the region today known as Kandiyohi County. Born in Stockholm, Sweden, in 1795, he was also the first known Swede to settle in Minnesota.

Minnesota was established as a territory in 1849 and admitted to the Union as a state in 1858. A commission was sent by Gov. Henry H. Sibley to select a site for the state capital. The group concluded that the townsite of Kandiyohi was the ideal choice, but St. Paul was selected instead. In 1861, Rep. Vincent Kennedy introduced a bill to move the capital from St. Paul to Kandiyohi, setting off a battle that would last until 1901, when construction began on the capitol building in St. Paul.

The Dakota War of 1862 began in Acton Township, Meeker County, on August 17. Having sold their land, the Dakota moved to a reservation from near New Ulm to near Granite Falls. Payments to the Dakota for the land were disbursed in Washington, DC. However, by the time the payment reached the Dakota people, it amounted to almost nothing. Traders refused to issue credit, the Dakota did not know how to farm, and their people began to starve. Four Dakota men traded gunfire with settlers in Acton, killing five. Chief Little Crow attempted to calm the men, to no avail. The Dakota wanted to fight, and Little Crow relented. Before the last of the Dakota surrendered, an estimated 77 US soldiers and 450 to 800 civilians were killed. The Dakota lost an estimated 150 people, with 38 hanged. An unlikely hero emerged. Guri Endreson, a 49-year-old Norwegian woman, survived a Dakota attack and made her way to the stockade in Forest City, saving lives along the way.

In 1870, Monongalia and Kandiyohi Counties merged, taking the name Kandiyohi. This was also the year Willmar officially became a town thanks to the St. Paul & Pacific Railway. Though the rails arrived in 1869, it was not until the following year that Willmar began its development in earnest. The young railroad town experienced rapid growth as more and more settlers moved in, bringing with them stores, industry, service, and worship.

In the decades since its founding, the hardy and steadfast people of Willmar have survived and thrived. The grasshopper plague of 1876 and 1877, the Great Depression, multiple wars, explosions, fires, tornados, floods, and countless other calamities were no match for those who called Willmar home. Differences were settled, new residents were welcomed with open arms, and those who have left were sent with best wishes and remembered fondly. Businesses have been built, inventions developed, and friendships found. Churches have served, medical needs were met, and neighbors were helped. Homes were built, parks set aside, and community organizations met needs. Moreover, while those are written here in the past tense, Willmar continues all that and more, bolstered by the foundation left by those who have come before. As Willmar continues to move into the future, we can only dream of the story we will weave together, to be celebrated by generations that will come long after all of us.

One

WILLMAR BEGINS

As is the case with any community, Willmar progresses on the shoulders of those who have come before. Every community has a list of firsts, such as the first settler, the first home, the first business, and countless others. Each generation has a list of firsts its own. In the 1910s, perhaps it was the first fire truck. In the 1970s, it was the first personal computer. Each successive generation makes its mark and builds on the existing foundation to continue moving forward.

There are certain firsts that can only occur during the infancy of a community. This chapter is dedicated to those pioneer firsts from which all others would come. Willmar was founded on the prairies that still reside west of the town proper. First, the Native Americans would arrive. In multitudes of ways, they differed from residents now. Yet at their core, many of the same values and desires that folks cherish today were of the utmost importance to them. Some examples include the love of family, the sense of community, and the desire to live a rich and full life. They faced similar struggles, like protecting their children, feeding their families, and having enough clothing to keep warm. In time, their world would change. Eventually, white settlers would make their way to the region and fight for supremacy.

Change is a constant and inevitable reality. There is nothing on the earth that is immune to it. Therefore, people press on in search of an existence that is meaningful amidst the change, whether it is faith or spirituality, a desire to be remembered long after they are gone, or to create a legacy in the manner in which they teach and shape their children. In the end, deep down, people are all the same.

People have the privilege of peering at the past to build a better future. They can find inspiration in the strength of their predecessors, who instead of giving up in the face of difficult or even catastrophic circumstances stood up tall and made their little piece of the world a better place. Through their bravery, the land we now call Willmar sprouted forth.

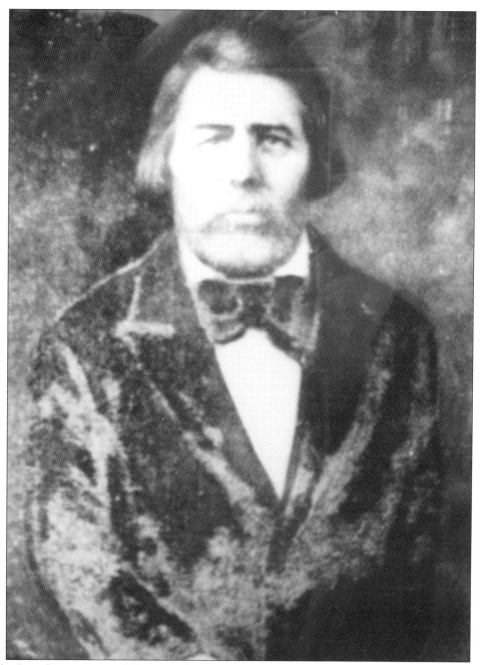

The first white man recorded to visit the area was Jacob Fahlstrom. Known to the Dakota people as "Yellowhead" and to white settlers as the "Swede Indian," Fahlstrom was also the first recorded Swede to set foot in Minnesota. Born in 1795 to a well-to-do family in Stockholm, Fahlstrom left home with a spirit of adventure. He became a fur trader for Hudson's Bay Company and the American Fur Company, eventually making his way to Fort Snelling in St. Paul. There he became a mail carrier to the Lake Superior region. In 1837 or 1838, Fahlstrom was converted, becoming a missionary to the Native Americans. It was in this capacity that he made his way to Kandiyohi County. Fahlstrom died in 1859. (Courtesy of the Minnesota Historical Society.)

This photograph, believed to be taken in the early 1860s, shows Taoyateduta, also known as Chief Little Crow. As leader of the Mdewakanton Dakota people, he agreed to lead the tribes through the Dakota War of 1862. Little Crow had a role in the Treaties of Traverse des Sioux and Mendota of 1851, which moved his band to a reservation near the Minnesota River. He attempted to live peacefully under the treaty by becoming a farmer and joining the Episcopal Church. He was killed on July 3, 1863, while picking raspberries with his son near Hutchinson, Minnesota.

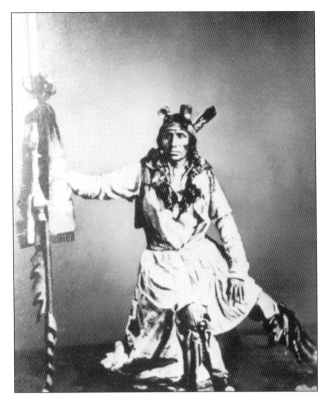

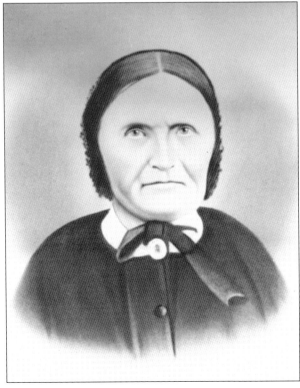

Guri Endreson, an emigrant from Norway, settled near Solomon Lake in 1857. The Dakota War of 1862 left her husband, Lars, and son Endre murdered. Having hidden in a cellar hole with her toddler, she was not discovered. As she and her wounded son Ole sought refuge, she came upon and saved the lives of Oscar Erickson and Solomon Foot. She continued to travel, searching for more survivors. Eventually reaching the stockade at Forest City, her courage earned her the title "Heroine of Kandiyohi County."

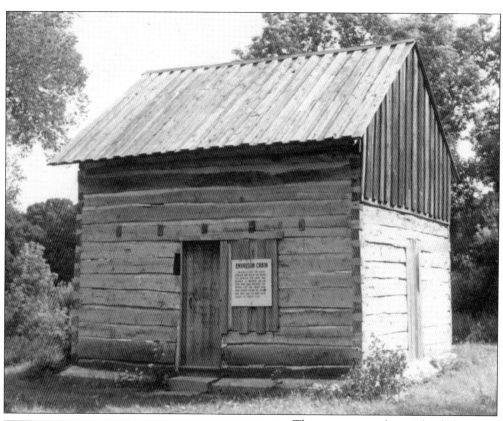

This one-room cabin with a loft was completed by Lars and Guri Endreson in 1858. The cabin still stands, allowing modern residents and visitors a peek into the daily life of Guri and her family. The cabin, pictured in 1965, has been listed in the National Register of Historic Places since 1986.

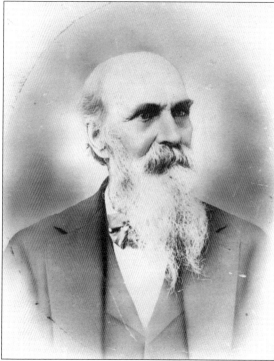

Pioneer Solomon Foot was 78 when this photograph of him was taken in 1901. Foot was the first settler to reside near the lake that now bears his name. Having been rescued from death by Guri Endreson during the Dakota War of 1862, Foot went on to become a member of the Kandiyohi County Old Settlers Association. Founded in 1897, the association was incorporated as the Kandiyohi County Historical Society in 1940. This is the same organization that continues to serve the area today.

This 1880s photograph shows Albert E. Rice sporting a handlebar mustache. Rice served as president of the Bank of Willmar, a Kandiyohi County senator, and as lieutenant governor of Minnesota. He was noted for sponsoring legislation that broke up railroad monopolies that owned the grain elevators and had control of the markets. This legislation paved the way for grain cooperatives to begin serving area farmers.

As it is today, civic events provided businesses an excellent opportunity to show community support as well as attract customers and generate name recognition. This photograph from the 1890s shows two unidentified men displaying toilets and a radiator. The event was the Willmar Street Fair, and the company was J.H. Wiggins Heating and Plumbing. The operation was very successful and grew to serve customers throughout Minnesota and the Dakotas.

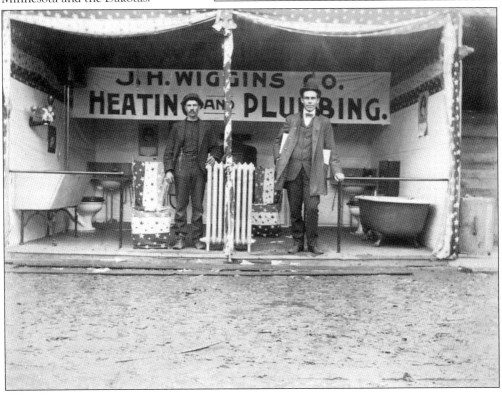

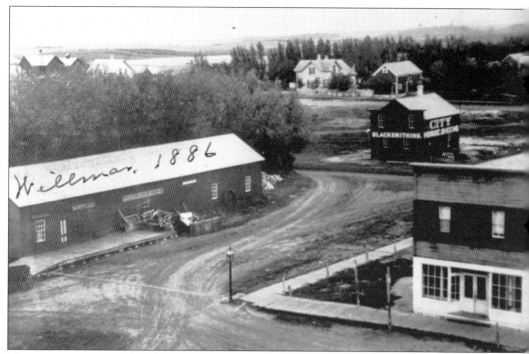

This panoramic view of Willmar in 1886 shows the city in its 16th year. While not an official birth date, it was in 1870 that development of Willmar began in earnest. This burst of new growth was considered to mark Willmar's founding year, when the town became more than a few stores

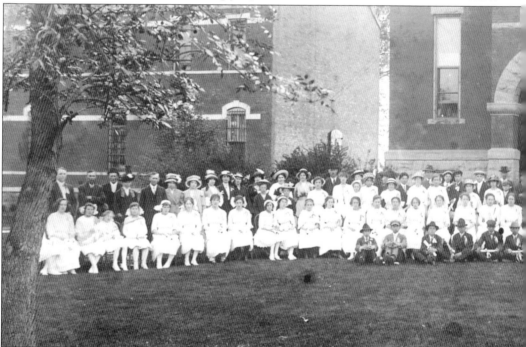

Numerous individuals pose for a group photograph in front of the Kandiyohi County Courthouse in 1898. The photograph, taken during a rural school graduation, had an excellent backdrop. The

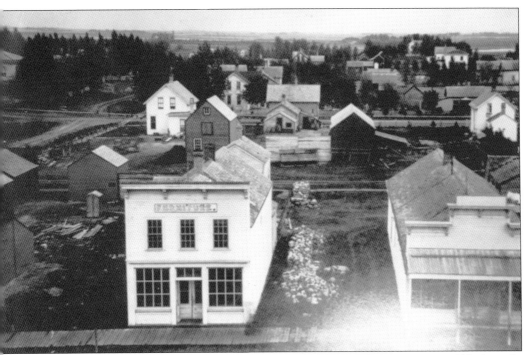

to serve construction crews with the railroad. Clearly visible are a furniture store and blacksmith, one a necessity and the other a luxury.

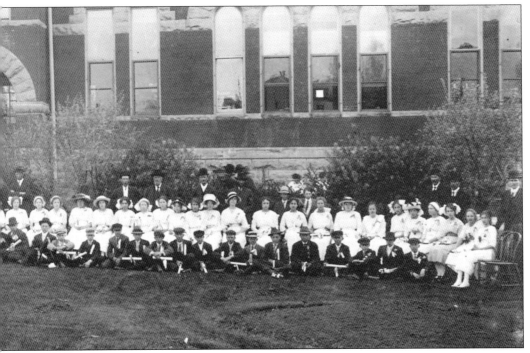

courthouse was a source of great pride for residents across the area.

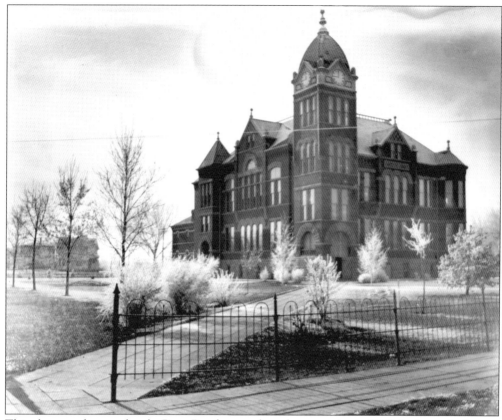

This photograph was taken by Peter Bonde on a glass plate negative in 1900. It shows the beauty of the Kandiyohi County Courthouse in Willmar on a frosty winter day. The courthouse was constructed in 1890, twenty years after Monongalia and Kandiyohi Counties merged in 1870. In 1901, construction began on the state capitol in St. Paul. The new state capitol would mark the end of a 50-year battle to make Kandiyohi instead of Willmar the state capital of Minnesota.

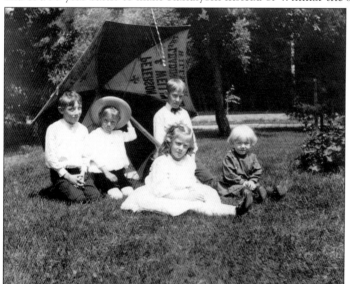

A group of young Willmar residents sits patiently in this 1905 photograph on the courthouse lawn. Their summery poses are shaded by an advertising umbrella provided by the Peterson and Wellin Leading Store. In all seasons, the children of Willmar enjoy the outdoors and have since the early days of the city.

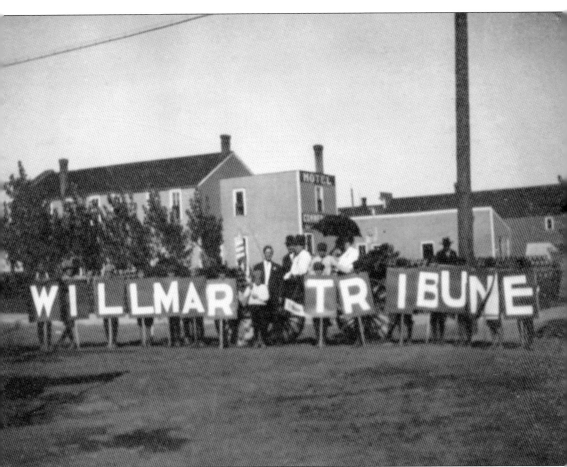

The *Willmar Tribune* began operations in 1895 and was a four-page weekly Populist newspaper. Along with local interests, it also provided current events in Sweden, Norway, and Denmark to readers. At that time, the largest ethnic group in Willmar was Scandinavian. Introduced by Dr. Christian Johnson, the paper battled for supremacy over several competing newspapers. In the end, it outlasted competitors and continues to operate today. This group of youngsters holds letters spelling "Willmar Tribune" during the 1908 Willmar Street Fair.

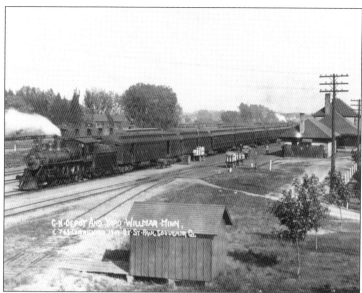

This 1909 postcard view of the Willmar depot shows a Great Northern steam train blowing its stack. Cargo and passengers are in the yard waiting patiently to board. Postcards began to blossom in 1901 with an order by the postmaster general. Willmar, not unlike other towns throughout the nation, could now benefit from the advertising value postcards provided.

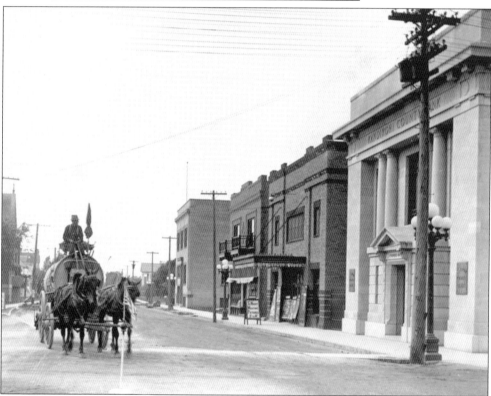

A Willmar man drives a horse and wagon near the intersection of Fifth Street and Litchfield Avenue in the early 1900s. By this time, Willmar had come into its own, offering everything needed for comfortable city living. In the background, Vinje Lutheran Church stands to serve the spiritual needs of Willmar residents. The Kandiyohi County Bank protects their money. Even moving pictures were available at the State Theatre at a cost of 5¢ and 10¢, providing grand entertainment.

Willmar was selected as a hub for the Great Northern Railway in 1869, and the initial growth of the rail yard lasted into the early 1900s. Here, a group of railroad employees works on a project to construct a roundhouse for the yard.

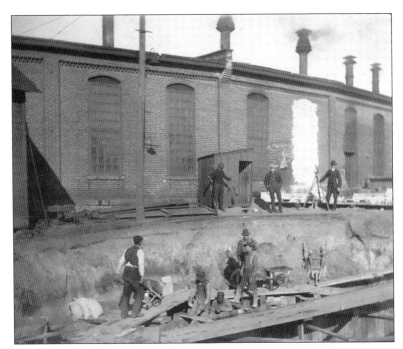

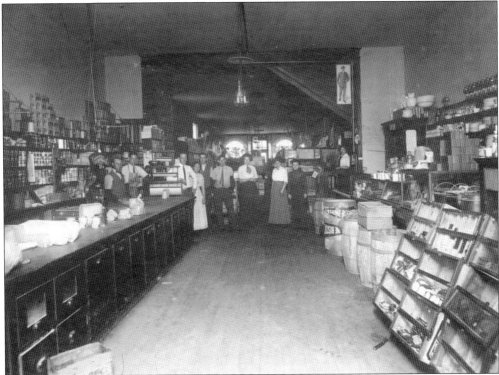

This photograph from the early 1900s gives a glimpse into one of the most successful business operations in its time. The Willmar Cooperative Mercantile Company, better known as the "Farmer's Store," was on the corner of Pacific Avenue and Sixth Street. The individuals in the photograph are unidentified.

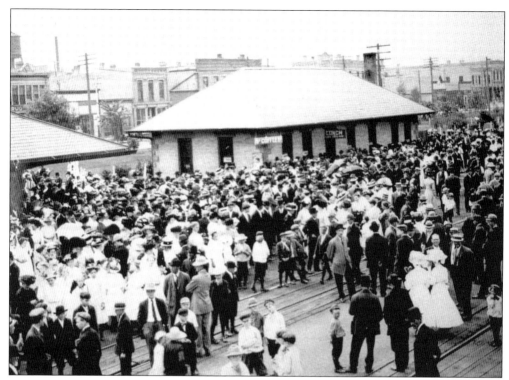

Former president of the United States Theodore Roosevelt spoke at the Willmar depot in 1910, drawing a large crowd. Following his departure from public office in 1909 and an expedition with the Smithsonian Institution through Africa and Europe in 1909 and 1910, Roosevelt returned to the United States to embark on a tour by train, campaigning for Republicans in state and local elections being held in November of that year.

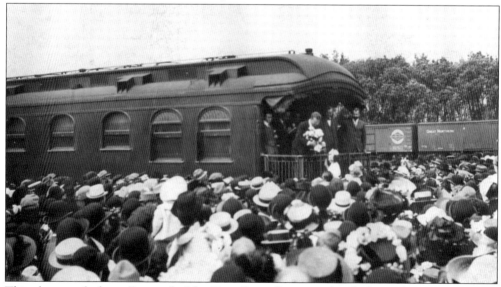

This photograph shows Roosevelt, "the Trust Buster," greeting locals during his 1910 train stop in Willmar. Roosevelt is known by many as the source of the quote "Speak softly and carry a big stick."

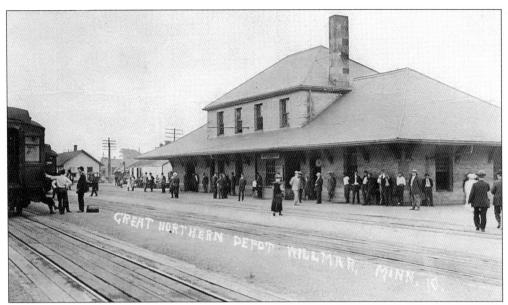

In late 1869, the rails first reached Willmar. The first tracks were laid by the St. Paul & Pacific Railway, which was purchased in 1870 by the Northern Pacific Railway. After the railroad went bankrupt in the Panic of 1873, James J. Hill collaborated with a group of investors to purchase it, and the group took control in 1878. It was renamed the Great Northern Railway in 1889. When this photograph of the Willmar depot was taken in 1915, Willmar had become a vibrant hub on the line, complete with a roundhouse and more than 30 passenger trains stopping here every day.

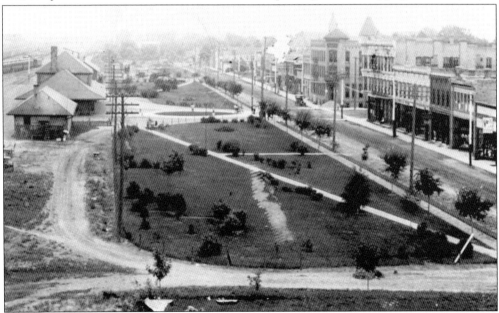

Willmar has long been known for its abundance of parks and picturesque outdoor spaces. This 1915 photograph shows an aerial view of Great Northern Park and the Willmar depot. Sitting alongside Pacific Avenue, it could be viewed from the outward-facing rooms of both the Merchants and Central Hotels. This photograph was most likely taken from the top of the grain elevator. The Kandiyohi County Office Building is on this site today.

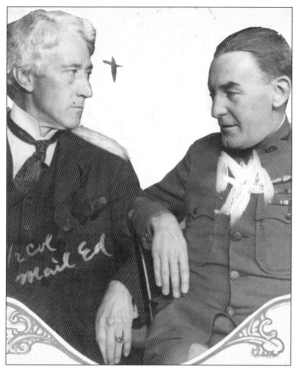

Col. Cushman A. Rice, son of Albert and Sophia Rice, is seen speaking with Judge Kennesaw Mountain Landis in October 1918, just one month prior to the end of the "Great War" on November 11, 1918. After serving in the Spanish-American War and World War I, Rice returned to Willmar, and provided in his will the property and funds to establish Rice Memorial Hospital in honor of his parents. The hospital began serving patients in 1937.

This 1918 photograph shows an interesting interior view of the Kandiyohi County Courthouse. A woman sits at her desk as county attorney Charles Johnson (center) and probate judge T.O. Gilbert (right) look on. Lettering on the office door reads "Probate Court." The photograph shows excellent detail in the woodwork, tin ceiling, and furniture of the office.

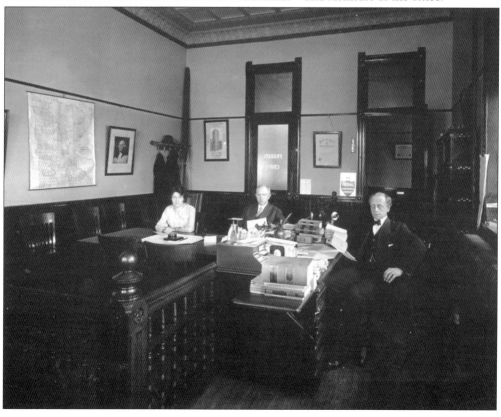

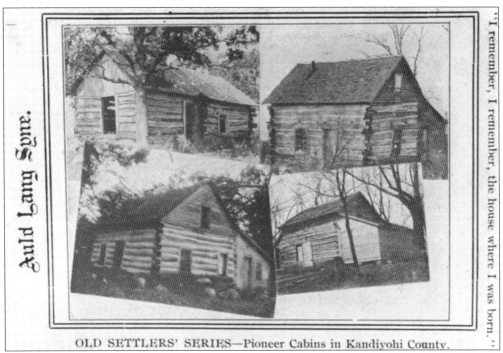

OLD SETTLERS' SERIES—Pioneer Cabins in Kandiyohi County.

This postcard from the 1910s features the words "Auld Lang Syne." Most are familiar with the words from hearing them so often as the clock strikes midnight on New Year's Day. However, the words when sung stand for the good old days, times gone by, or for old times' sake. As the postcard features four pioneer cabins in Kandiyohi County, the words are fitting.

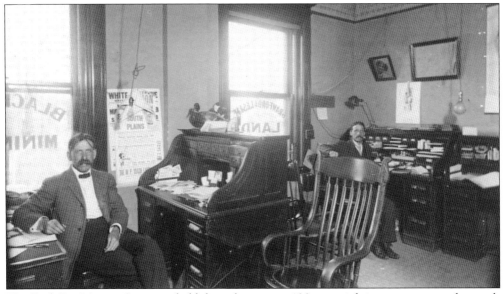

The Back Bay Mining Company held the rights to over 100 acres rich in copper ore on the north side of Lake Superior. The vice president of the company, A.C. Crawford, kept his office in Willmar and did his best to generate income for machinery by selling shares to local residents. He shared an office and was in partnership with J.E. Leslie, making up half of the Crawford and Leslie real estate company. The two men are shown hard at work in this image from the 1910s.

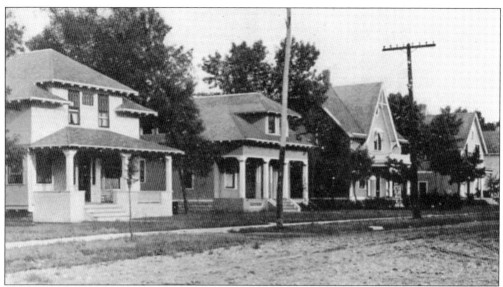

This postcard from the 1910s shows a picturesque residential Seventh Street West with attractive homes. An advertising piece, it was meant to show that Willmar had come into its own as a thriving city and offered both beauty and prosperity.

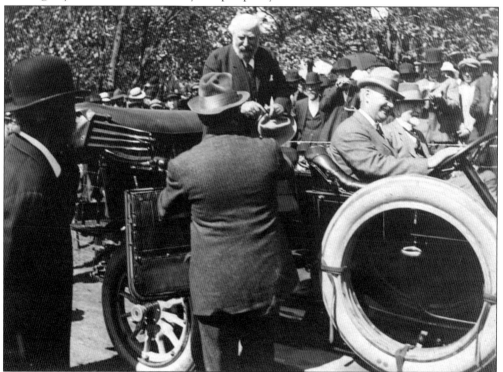

James J. Hill was a Canadian who went from rags to riches and was responsible for the vast expansion of railroads throughout the United States. While he did not bring a railroad to Willmar, he did choose Willmar as the site of the division headquarters on his Great Northern line. Hill is shown here riding in a car driven by D.N. Tallman and greeting residents. The visit was part of the Kandiyohi County Fair in 1914.

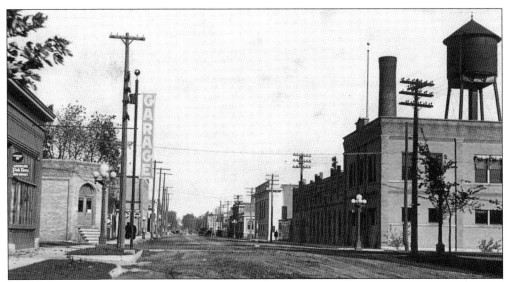

Looking east on Litchfield Avenue, this was the street on which the Willmar Power Plant sat, along with many other operations. This 1910s photograph shows a dirt street, the plant, the Handy Lewis Garage, and the Modern Creamery. The first utility works and commission were established in 1891 and began constructing waterworks. By 1889, Willmar residents were clamoring for power, and Municipal Utilities began to deliver on that desire in 1895. As the years passed and the city grew, the commission grew and expanded with it. The commission has continued to serve the community since its approval on March 7, 1891.

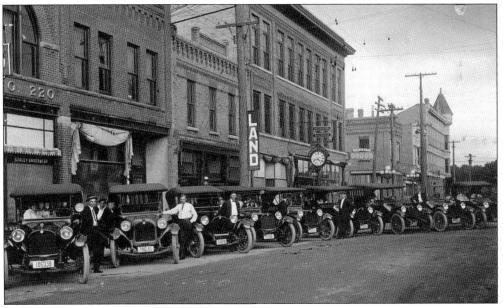

This image from the early 1920s shows a sight that would have been something grand to see. Nine new Dodge automobiles line Fourth Street South. Automobiles were still a novelty, and the opportunity to see so many of them would have been a large draw. Dodge began as a brand in 1914. Also seen in the photograph are several local landmarks including the Bonde Building, the land office, the Medical Block, the Carlson Bros. Drug Store, the meat market, and the Central Motel.

It is not known why this Elgin Six convertible is festooned with streamers and flags. It might have been part of an Independence Day celebration in the 1920s. J. Melvin Johnson, partial owner of the Johnson-Erickson Garage, sits behind the wheel.

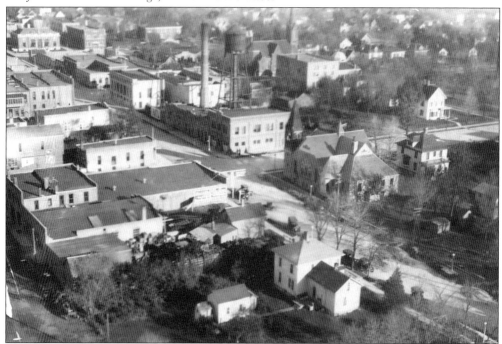

A young town full of hope and promise is captured by photographer Einar Brogren in the 1920s. City hall is shown under the water tower and across the street from the Presbyterian church. Also visible in the upper left is the *Willmar Tribune* and the post office. Vinje Lutheran Church is near center.

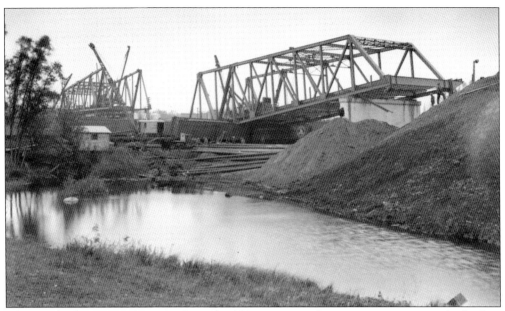

This new bridge on First Street in the early 1930s experienced a major construction setback when it collapsed on the rail yard below, crushing several railcars. The steel-framed bridge had a rough beginning in several ways. The funding needed to build the highway leading to and from the bridge was not provided, and the bridge stood alone for several years.

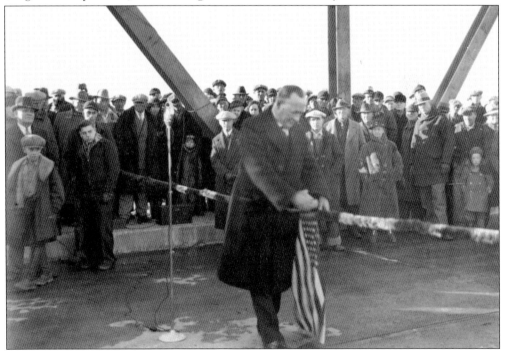

Willmar residents turned out in droves to attend the grand opening of the new bridge, which was held several years before the highway would reach it. The bridge had gained fame after being featured in *Ripley's Believe It or Not!* It was called by Ripley's "The Bridge That Leads to Nowhere." Only when the funding came through was the bridge able to overcome the dubious honor.

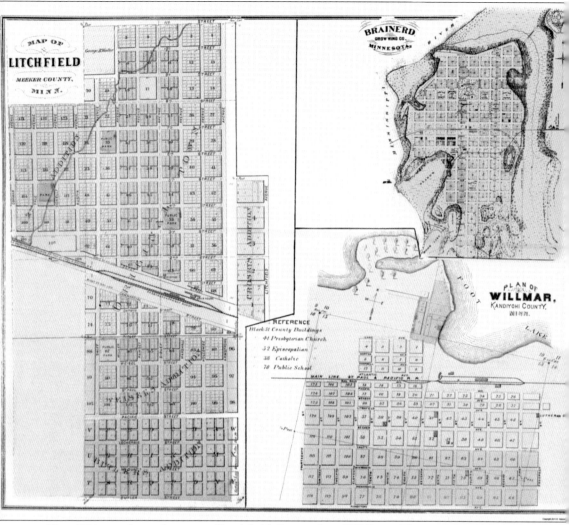

This 1874 map shows the cities of Litchfield, Brainerd, and Willmar. The town would have been only four years old at the time this map was printed. It is interesting to note that the map only specifies the county buildings, the public school, and three churches. The railroad is clearly marked. Pictured on the map are several streets that would become a thriving downtown area, including Litchfield, Benson, and Trott Avenues. (Courtesy of the Minnesota Historical Society.)

Two

WILLMAR WORKS

America has always been a conglomeration of very different people. It is a melting pot, with people's ancestors hailing from all around the world. They come together, though, for family, community, and camaraderie. Anything worthwhile that is made is done so through effort. Everyone has their own specialties and gifts, but they serve through the work of their hands, both individually and collectively. Each individual specialty works together for the whole.

As time passes, some knowledge and skills become obsolete. Making horseshoes was a hugely important skill to possess when folks relied on the horse for transportation. Then the skills, knowledge, and hard work of others created the automobile, and an entirely new profession, the internal combustion engine mechanic, took the place of the blacksmith. It is called progress, and it can only be achieved as all work together, adapt, and overcome.

Some work remains constant: people must work to have food to eat and to have income. It may be slightly different now. In the distant past, the work done with hands would be used to barter for other needed things. Now, people must earn money for their work to pay others for those things that they create with theirs. It may be a simplistic illustration, but it is true nonetheless. The Midwest has long been known for its exceptional work ethic. Much of the credit for that is due to the work ethic of mothers and fathers who taught the value of honest work for honest pay.

Chapter two examines the work done by Willmar residents, from the pioneer retailers to the big box stores and internet vendors that exist today. Countless businesses have come and gone. Some barely lasted overnight, while others that were begun in the earliest days of the city continue today.

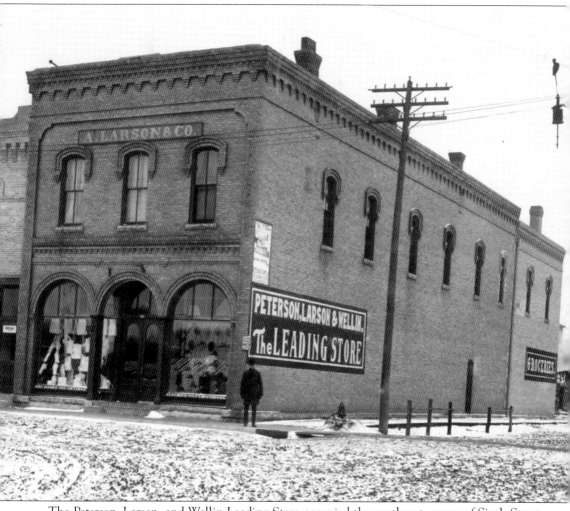

The Peterson, Larson, and Wellin Leading Store occupied the southeast corner of Sixth Street and Pacific Avenue. Shown here in the 1890s, the general merchandise store was considered one of the finest and largest of its kind in Willmar. Not seen in this photograph is the printing shop of the *Willmar Argus*, two doors to the left of the store. The *Argus* was an early Willmar newspaper that would later become the *Willmar Gazette*.

John Dehlbom and John Samuelson began the first brickyard in Willmar in 1888 near Trott Avenue and Tenth Street. The clay supply needed to operate was depleted three years later. Prospecting discovered a clay deposit suitable for the operation, and the plant was moved. This new plant operated under several ownership changes until the brickyard was finally closed in 1950. Though most of the operation is now gone, travelers heading south on Highway 12 can still see a chimney standing at the brickyard site. This photograph of the site was taken in 1960.

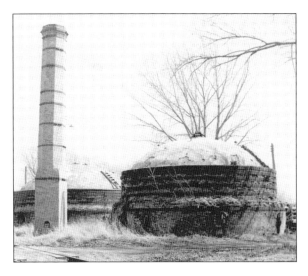

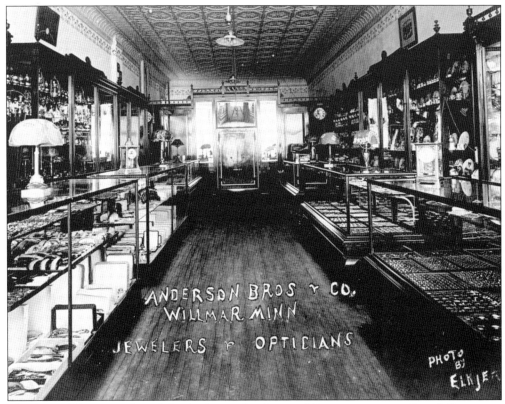

This beautiful interior shot of the Anderson Brothers and Company store on Fourth Street was taken in 1895. At this time, the store was three years old. The brothers were renowned as the leading jewelers and opticians in the area. Along with providing their services and wares to the community, the brothers were also chosen as the time inspectors for the Great Northern Railway.

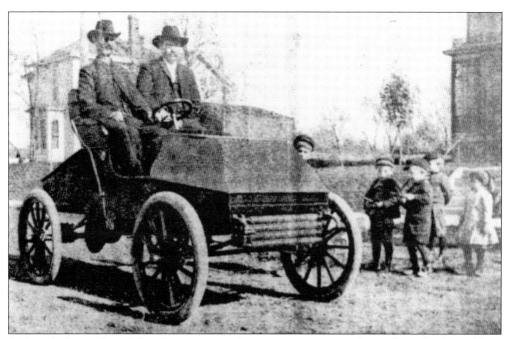

Although the quality of the above image is low, one can imagine the pride in the face of Lars (Louis) Halvorson, owner and inventor of this contraption, as he passes by a group of awed young children. One can only wonder why his great invention did not end up making Willmar the automobile capital of the world instead of Detroit. Halvorson was also a carpenter and mechanic who in 1898 opened the Willmar Gasoline Engine Works. The lithograph from 1900 below displays the "Portable Gasoline Engine" manufactured by the firm. The company experienced great success for several years, and Halvorson had even announced that he was making plans for an automobile powered with an eight-horsepower engine of his design. The company was sold in 1905 to J.F. Millard, vice president of the Kandiyohi Bank. It was renamed the Willmar Iron Works. Halvorson later opened an automobile repair shop in Willmar and sold Maxwell and, eventually, Chevrolet automobiles.

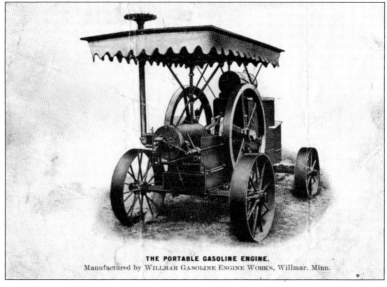

THE PORTABLE GASOLINE ENGINE.
Manufactured by WILLMAR GASOLINE ENGINE WORKS, Willmar, Minn.

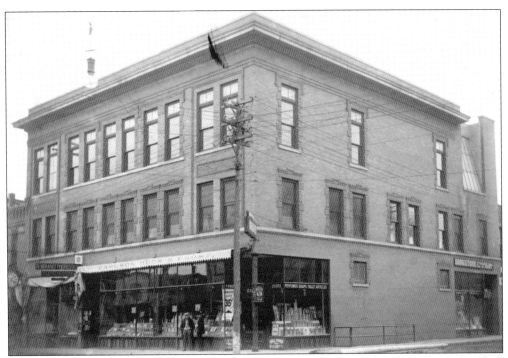

This early 1900s photograph shows the Carlson Bros. and Frost Drugstore. In addition, the building on the corner of Fourth Street and Benson Avenue housed the Rembrandt Photo Studio and several other local businesses. Dr. E.S. Frost was a pioneer physician and the local surgeon for the Great Northern Railway. The business began operation in 1888.

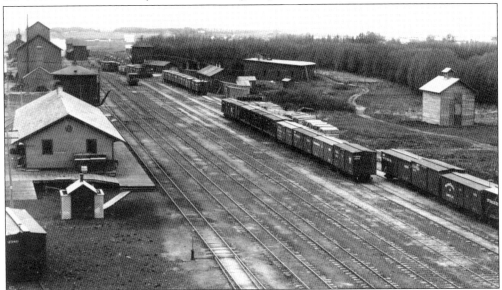

By the time this photograph of the Willmar Rail yard was taken in the early 1900s, Willmar had fully established itself as a railroad town. Workers here sent and received shipments every day of products from dairy to produce as well as items such as furniture and building supplies. Operating a shipping hub, a repair facility, and a passenger depot required a varied range of employees, including mechanics, carpenters, loaders, and depot agents, to ensure smooth operation of the railway.

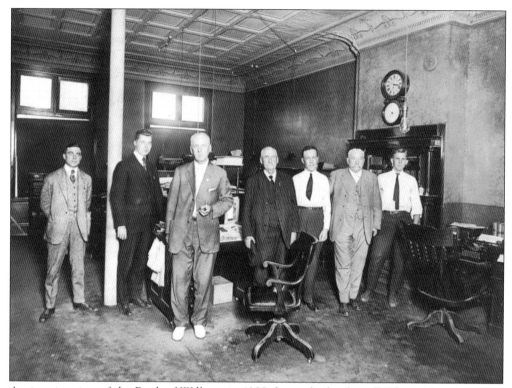

An interior view of the Bank of Willmar in 1908 shows the bank staff. The opulent beauty of the tin ceiling contrasts with the utilitarian hanging lights and rough flooring. Though most of the men are unidentified, A.E. Rice stands second from right. The Bank of Willmar was the first bank in the city, originally organized as a private institution in 1873. That changed in 1882, when it became a state bank.

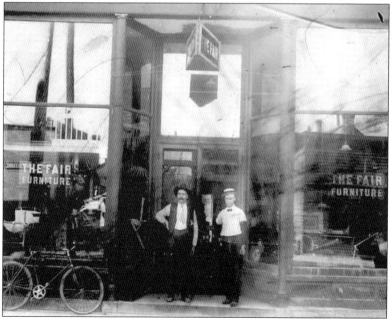

Two men stand in the doorway of the Fair Furniture Store in 1910. According to the 1910 City Directory, the business was located at 321 Benson Avenue. Of special note is the clothing worn by the two men, as well as the bicycle resting in front of one of the large display windows.

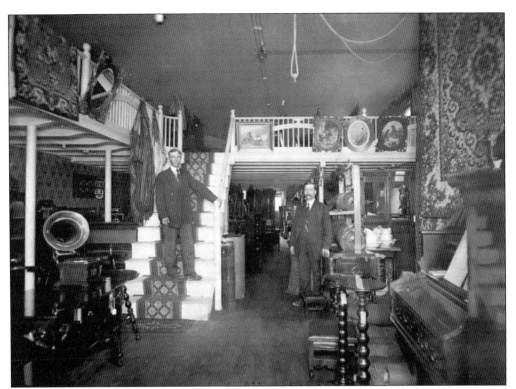

This photograph is believed to have been taken in 1910 inside the Fair Furniture store. The wares shown, including rugs, organs, a record player, and other home decor items, give credibility to that belief. The two men standing in the store are unidentified.

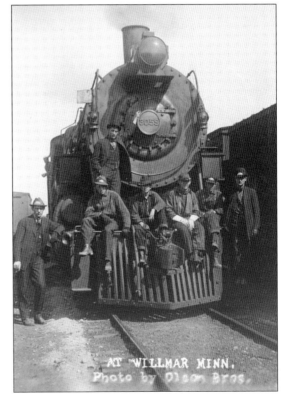

Great Northern Engine 3059 sits on the tracks in Willmar, a majestic machine with steam billowing out of its stack. Engineer Frank Onril, as well as Jack Noland J. Willson and Ari Larson, join three other unidentified men to pose for this Olson Brothers photograph taken in the 1910s.

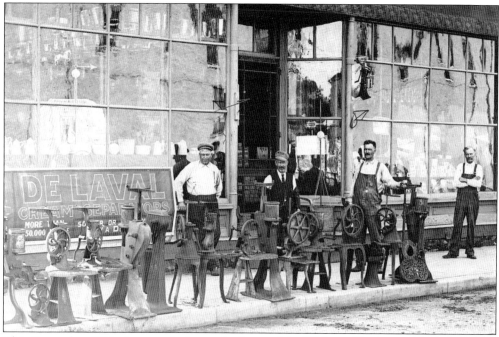

This September 1911 photograph shows the front of the Willmar Hardware Company at 118 Sixth Street, between Pacific and Benson Avenues. From left to right are unidentified, Albert Lund, Martnus Hanson, and Christ Otterness. Willmar Hardware Company was registered with the State of Minnesota on April 25, 1902. Albert Lund was listed as president of the firm. A sign proudly announces De Laval Cream Separators, and machinery lines the sidewalk.

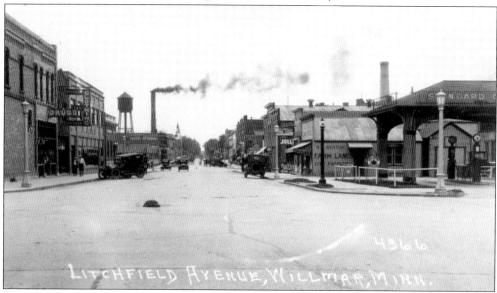

A number of local businesses are featured in this 1920s photograph looking west down Litchfield Avenue. These include Erickson Clothing, Osmundson Garage, the land office, a shoe shop, and the early Standard Oil Company station. By the time this photograph was taken, the automobile had all but replaced the horse-drawn carriage within the city. In the distance, the power plant smokestack is billowing a cloud across the horizon.

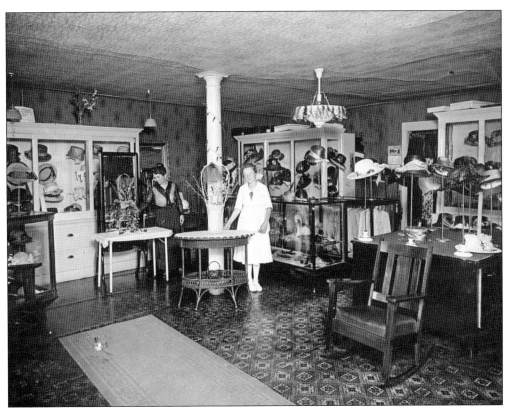

The warm and inviting atmosphere of the millinery store can be seen in this image from 1920. The store was operated by Emma Berkness. The women of Willmar at that time had an excellent selection of beautiful hats right in line with the fashion of the day. The two women pictured are unidentified.

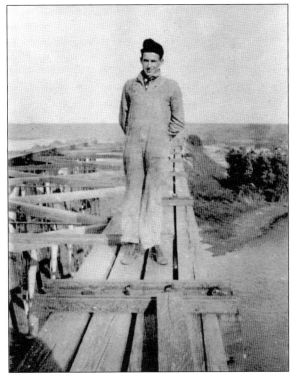

Bryan Sperry, the youngest son of pioneer settler and soldier Albert H. Sperry and his wife, Jennie, stands atop a railroad bridge being constructed in Willmar in 1921. The Sperry House, built by Albert in 1893, was transferred to the Kandiyohi County Historical Society upon Bryan's death in 1970. Visitors to the historical society complex can still tour the house the Sperry family called home.

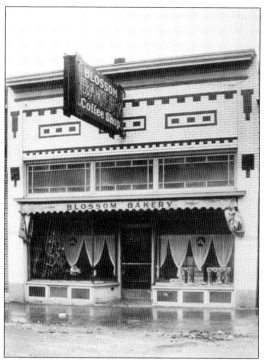

The lovely brickwork of the Blossom Bakery and Coffee Shop on Litchfield Avenue is shown in the 1928 image at left. The bakery was a well-loved institution known for its exceptional baked goods. Jake's Pizza now operates in the building. The white and blue facade survives. The Blossom Bakery back room is shown below upon the bakery's opening in 1928. The bakers are Severin Vatne (left), from Vatne, Norway, and his cousin Carl Olson. The bakery was owned by Olson and his wife, Selma. The two coal-fired ovens were large enough to handle 300 loaves of bread. The large mixer on the right, a Champion Number Two, had a chute that carried flour up from the basement. In its day, the bakery was a modern operation with the best equipment. A close look reveals that Olson is wearing a Very Best Flour apron; This flour was produced by the W.J. Jennison Company on the banks of the Pomme de Terre River in Appleton, Minnesota.

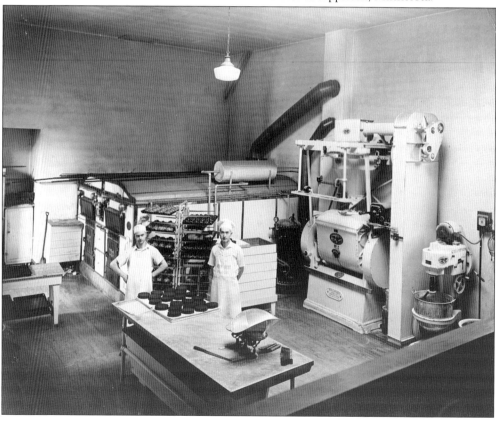

This portrait of E.C. Wellin, a prominent local businessperson, was taken in the 1920s. Wellin was lovingly known as the "Father of Willmar's Parks." A fervent lover of the beauty of nature, Wellin had a park of his own in southwest Willmar. He pushed for shade trees and orchestrated the planting of hundreds of elm trees on Willmar boulevards. Wellin served as park commissioner for 20 years, was Willmar's mayor for 11 years, and even served as postmaster and superintendent of Fairview Cemetery. He was a partner in the Larson, Peterson, and Wellin store, which was opened following his arrival in Willmar in 1885.

It is disputed who deserves credit for the electric telephone, but the invention was patented by Alexander Graham Bell in 1876. In the beginning, the telephone was primarily used for post offices, railway stations, newspapers, and other government entities. The telephone exchange and switchboard came into its own in the late 1800s. By the late 1930s, when this photograph was taken, most relatively large towns had telephone service available to customers. The Northwestern Bell Telephone Company was at 100 Fifth Street West in Willmar.

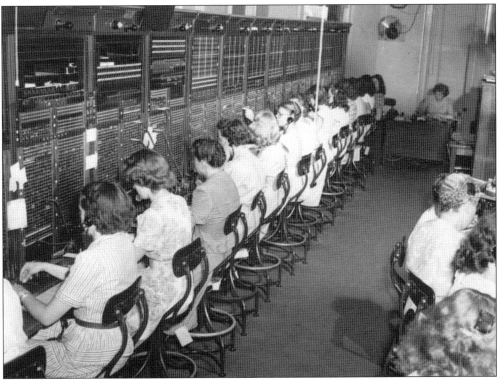

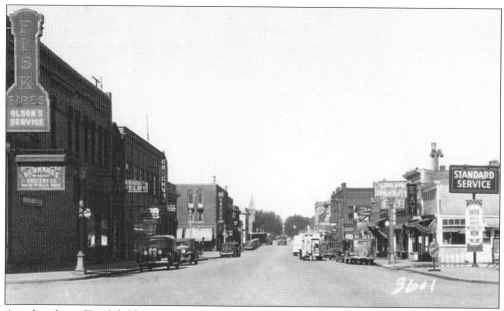

Another shot of Litchfield Avenue from the late 1930s shows a bustling little city among the lakes and trees of the surrounding countryside. A vast number of businesses had emerged, including Olson's Service, Berkness Grocery Company, Paffrath's Jewelry, the Lakeland Hotel, Manly's Restaurant, and Blossom Bakery, among others.

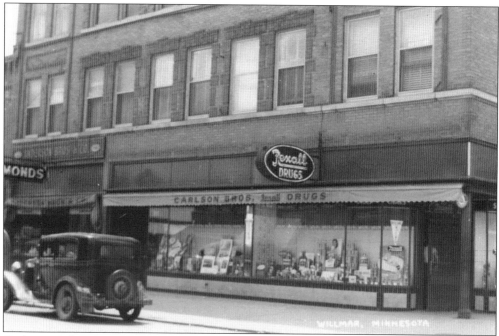

Carlson Brothers Drugstore continued to thrive into the late 1930s, as seen in this photograph from that time. No longer a completely independent operation, it had received license to use the Rexall brand name. Rexall's roots are in the federation of United Drug Stores, which was essentially a retail cooperative. By using the Rexall name, local drugstores could purchase and sell Rexall products.

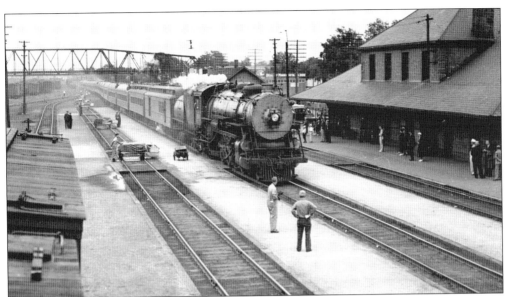

The railroad was a major employer in Willmar and continues to be today. This photograph was taken in 1930. It shows the *Empire Builder* passenger train pulling into the station near the Willmar depot. The train was inaugurated in 1929 by the Great Northern Railway to honor founder James J. Hill. Workers in the yard wait to ice the train for its journey to the Pacific Northwest.

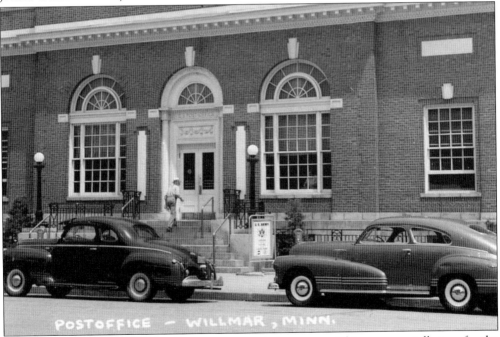

During World War II, the post office was extremely important. This was especially true for the members of the armed forces and their families. Letters became much more than simply a means of communication. They provided a sharing of emotions and feelings that were typically saved only for special occasions. Families waited earnestly for news from loved ones. A soldier's morale was bolstered by a connection to their lives back home. The Willmar Post Office, shown in this 1945 photograph, served as a critical conduit between Willmar and those serving their country.

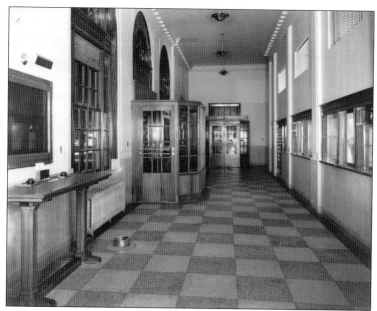

Behind the front windows of the Willmar Post Office, employees would complete their duties within this large workroom. A gated interior room adjoins the work counter where various postal tools can be seen, including a sizeable scale, all waiting silently to serve the public. This photograph was taken in 1940.

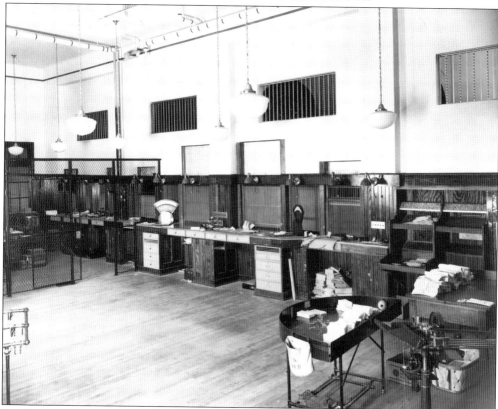

Postal customers enjoyed an entirely different view than those working behind the clerk's windows, seen on the right in this photograph. Also taken in 1940, the image captures the front room or public area of the Willmar Post Office. This area was beautifully decorated, adorned with fine woodwork, large windows, and radiator heat for comfort during the colder months.

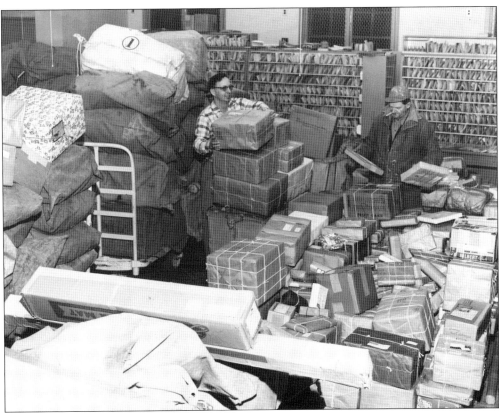

Post office employees are hard at work in this *Willmar Tribune* photograph taken on December 24, 1957, perhaps the busiest day of the entire year. Mailman Luther Norbie (left) picks up a large package, while Les Herrick (right) sorts a group of smaller ones. Herrick was the contract mail hauler, carrying packages from the train depot to the post office.

Helen Ruth Hande poses as she heads to work at the Willmar State Hospital in 1940. When it opened in 1912 as the Willmar Hospital Farm for Inebriates, treatment included working on the self-sustaining farm raising crops and livestock. An increasing population and a stream of new residents sent by rail from other Minnesota hospitals in the 1920s and 1930s generated the need for construction of new buildings. Those same buildings today make up the MinnWest Technology Campus. MinnWest is a conglomerate of companies that purchased the buildings to save and reuse them after the hospital began closing in 2002.

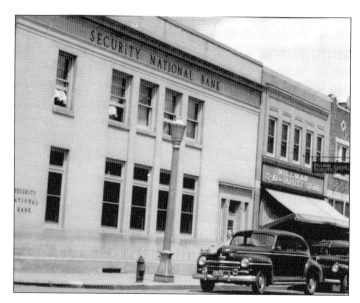

World War II ended in 1945, the same year this photograph was taken. The shot looks northeast from Fifth Street in the heart of downtown Willmar. Despite numerous Willmar men leaving home for the war, businesses in town continued to operate thanks to the support of the men and women left behind.

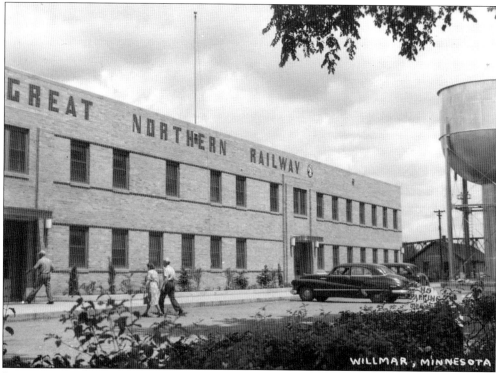

In 1948, a newly constructed Great Northern Railway depot took the place of the original depot. The new depot was built directly in front of the old, and the old was not demolished until the new depot was operational. In the years since 1948, the depot has become a landmark and symbol of Willmar and its roots as a railroad town.

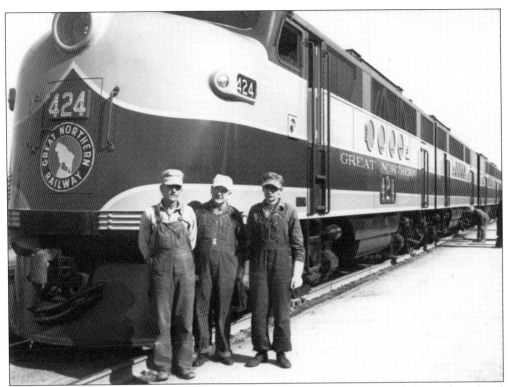

This iconic 1940s Willmar photograph displays the streamlined beauty of the modern diesel engine, which was on its way to dominating the rails. In fact, diesel engines are still the industry standard today. Standing in front of Great Northern Engine 424 are, from left to right, brakeman H.W. Flersthura, fireman Roland Lusk, and engineer Robert Conway.

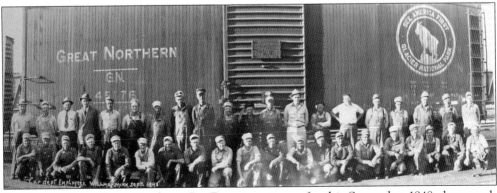

Employees of the Great Northern Car Department pose for this September 1948 photograph featuring one of the cars they built. Great Northern's marketing campaign of "See America First" is proudly displayed along with the mountain goat logo and "Glacier National Park."

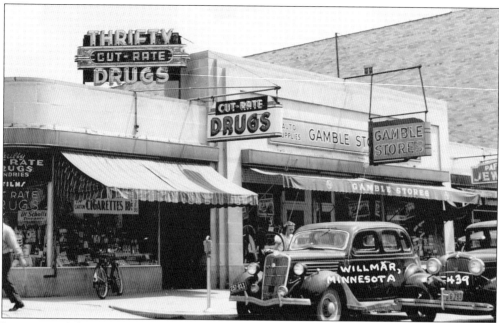

It was crucial during World War II that towns across the nation kept moving forward. Willmar was no exception. The art deco–styled Thrifty Drugs is open for business in this 1945 photograph. Along with serving public needs, the home front had a responsibility to the brave individuals who would be returning to Willmar, providing them a vibrant and optimistic home to return to. Also seen here are the Gamble Store and Paffrath Jewelers.

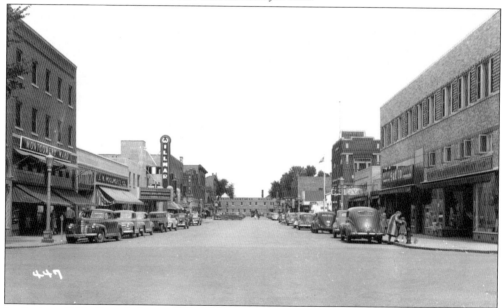

In the late 1940s, Fourth Street in downtown Willmar was a shopping destination. Along with the Willmar Theater and the *Willmar Tribune*, a number of national retailers provided their wares to the people of the city. National and regional businesses include J.C. Penney Company, Montgomery Ward, Buttrey's, F.W. Woolworth Company, and S&L Company. Local businesses include the Lakeland Hotel, Paffrath's Jewelry, and several others.

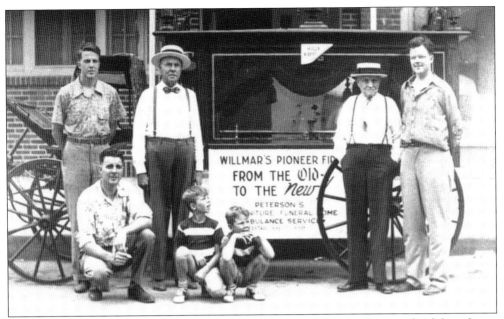

Andrew Peterson began a furniture business in Willmar in 1889. At the time, he did not know that his business would eventually become a funeral home. Nor did he know that it would live to become the oldest continuous family-owned business in the county, still serving the area today. Peterson added coffin sales to his inventory and eventually specialized in undertaking. He stands second from right in this 1950 photograph surrounded by three generations of his family, including a young Rolf Peterson (squatting at center). The horse-drawn hearse in the background was still used at the time in the Kaffe Fest Parade. Peterson Brothers Funeral Home resides today on Becker Avenue.

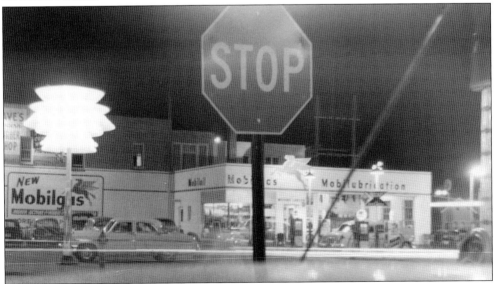

Esther Smith, a budding local photographer, took this picture in the 1950s. The Mobil station was on the corner of Third Street and Litchfield Avenue and was owned by Milford "Miff" Larson. Miff was honorably discharged as an airplane mechanic from the Army Air Corps and returned to Willmar following World War II to marry his wife, Audrey, and open his gas station.

What appears to be a Willmar traffic jam is captured in this late 1940s photograph. The businesses in the background include Coast-to-Coast Hardware, Dr. Sheldon Optometrist, and the Hamburger Shop. Peeking out in the background is the new Great Northern depot.

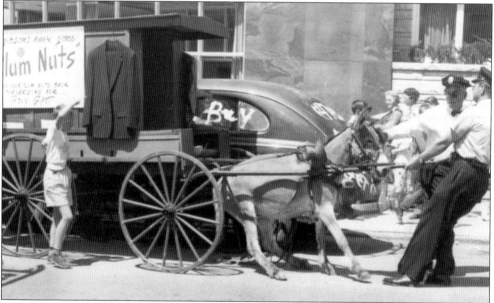

Two local police officers go above and beyond the call of duty in this 1950s photograph. The wagon, being pulled by two donkeys, advertises the R.E. Torgerson Clothing Company, which is the building behind the wagon. According to the sign, Torgerson's had gone "plum nuts." It can be assumed that the wagon was double-parked and local law enforcement sought to rectify the situation. The son of R.E. Torgerson, Tom, took over the store following his father's death. He would go on to charter Citizen's National Bank in Willmar. After selling the clothing store, Torgerson purchased an interest in the Holiday Inn of Willmar and transitioned to the hospitality industry. The company he began, Torgerson Properties Inc., known today as TPI Hospitality, continues to serve travelers and businesspeople throughout the country.

48

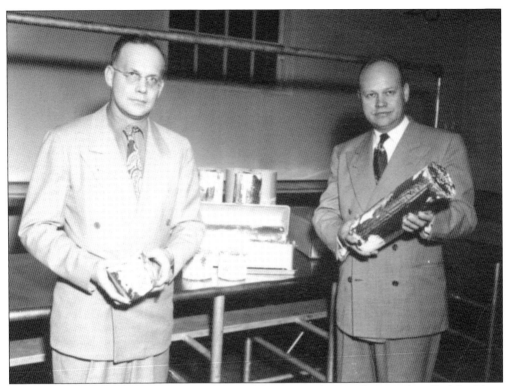

One would be hard-pressed to discuss Willmar history without talking turkey. Earl B. Olson (right) started with nothing but his work ethic and a dream and transformed them into a national company and today's largest employer in Willmar. He began raising turkeys in 1941 and purchased the Allstate Supply turkey plant in Willmar. He renamed it the Farmer's Produce Company. Under Olson's guidance, the company began expanding rapidly. By 1959, Willmar was considered the world's leading turkey company. Eager to expand his reach, Olson decided his company's name sounded too local, and he sought out a new brand name. At Thanksgiving, his wife, Dorothy, suggested he use the name of their daughter Jennifer, and Jennie-O was born. The company name officially changed to match the brand name on January 1, 1971.

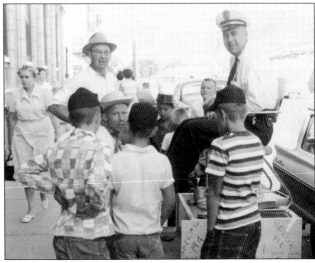

Several young entrepreneurs operate a shoeshine business on a Willmar sidewalk in this 1950s photograph. Most likely coinciding with Krazy Daze, an annual citywide retail sales event, a police detective takes advantage of their service. In the background to the left, Clint Haroldson looks on.

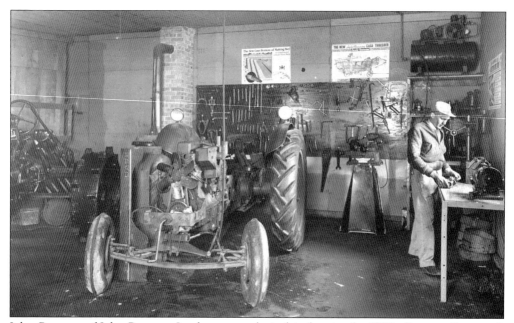

John Peterson of John Peterson Implement works in his shop in the 1950s. Born in Raymond, Minnesota, he began his career in construction. After he married Violet in 1936, the couple moved to Willmar, where he began working for a local implement dealer. After gaining experience, John opened his own Case dealership. He sold the dealership in 1968 and began a second career as a local realtor. Peterson passed away in 2007.

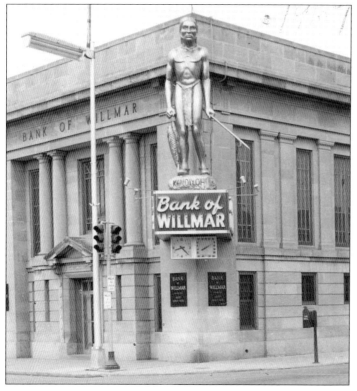

The Bank of Willmar, with its statue of Chief Kandiyohi, is pictured in 1957. Chief Kandiyohi was a fictitious Native American who became the symbol of the Kandiyohi County Bank. Local artist Eben E. Lawson was commissioned by the bank to create a sculpture of the chief in 1915. In 1956, Bank of Willmar president Norman Tallakson, had the 17-foot statue made from Lawson's much smaller original. It stood on its perch until it was donated to the city by First American Bank and Trust. The statue now resides in front of the Kandiyohi County Courthouse.

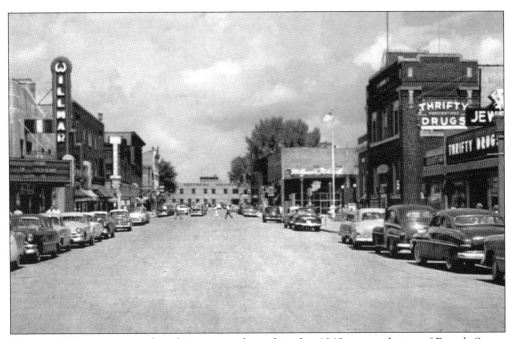

Postwar Willmar continued to thrive, as evidenced in this 1960 postcard view of Fourth Street downtown. Cars line the streets as pedestrians mingle along the sidewalks. Clearly visible is the Willmar Theater on the left. Thrifty Drugs and the *Willmar Tribune* building are on the right. In the distance, the Great Northern depot serves as a backdrop for the busy roadway.

Willmar residents patiently wait in line at the office of license registrar Don Webster in the Kandiyohi County Courthouse. In the days when everyone's license tabs were due at the same time, lines could grow exceptionally large. With the deadline looming in January 1961, these local folks were a small part of a line that remained long from 8:30 a.m. to 5:00 p.m. with no breaks.

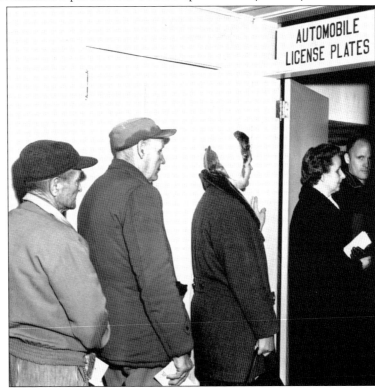

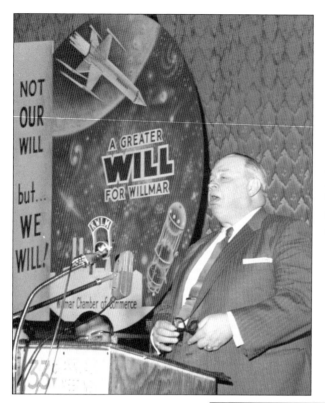

Don Hedlund, the retiring president of the Willmar Chamber of Commerce, speaks at the annual chamber meeting in January 1961. Incoming president Ray Pederson looks on. The meeting, hosted at the War Memorial Auditorium, featured a keynote address by H. Roe Bartle, mayor of Kansas City, Missouri, who encouraged the group to "Stand up and be counted." The Willmar Lakes Area Chamber of Commerce continues to be a vital organization in the community.

Willmar's Kandi Mall opened in grand fashion in August 1974. This photograph, featuring special guest Hubert H. Humphrey, was taken during the event. The group stands in Goldfine's Department Store, an initial mall anchor store. An unidentified representative of Goldfine's parent company stands next to the senator. Also pictured, from left to right, are Erv Goldfine, John Lindstrom, and Manny Goldfine. Goldfine's began in Duluth, Minnesota, in 1962. The well-loved brothers were known as "Soft Touch Erv" and "Easy Mark Monnie."

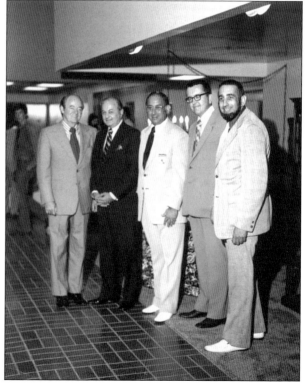

By 1980, Willmar was regarded as the hub of the region. It was enjoying a vibrant economy, bolstered by both local and national companies. One such company was Kentucky Fried Chicken. Now known as KFC, the restaurant remains in the same location on South First Street.

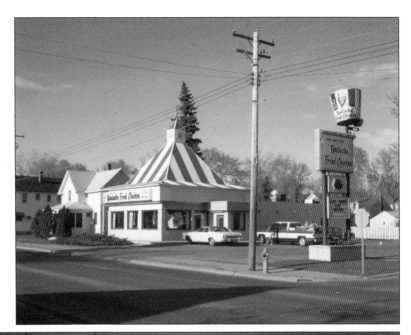

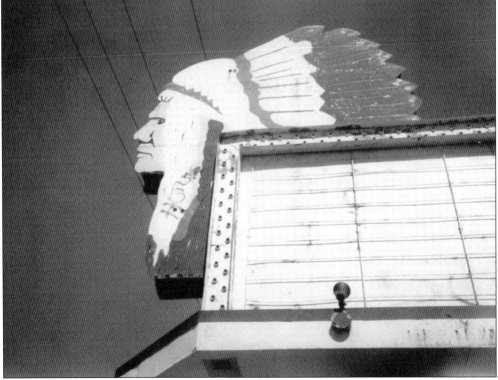

Along with the Willmar Theater downtown, Willmar was also home to an outdoor theater operated by the Willmar Amusement Company. The Chief Drive-In Theater opened in the 1950s. It had one screen and could accommodate up to 450 cars. The theater was on Nineteenth Avenue, where Oral Facial Surgery and a housing development now stand. The theater closed for business in 1986. This photograph was taken in 1987, prior to demolition.

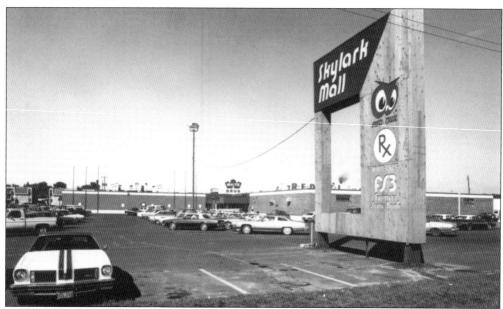

This photograph of the Skylark Mall was taken in the 1980s, when a Red Owl grocery store, White Drug, and Farmers State Bank were housed within it. The mall has seen many tenants come and go through the years. It is now home to an Affiliated Community Medical Center specialty center and several other local businesses. The mall was Willmar's first, having opened in 1964.

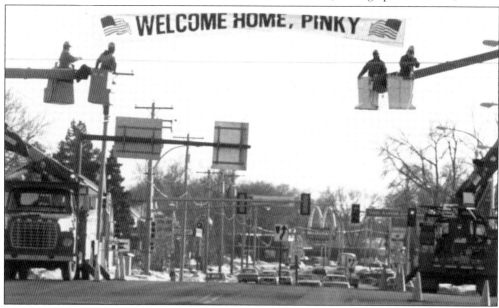

There are many exciting career options in Willmar. As George "Pinky" Nelson has proved, astronaut can be counted among them. Nelson is a 1968 graduate of Willmar High School. He then attended Harvey Mudd College in Claremont, California, receiving a bachelor's degree in physics. He earned his master's and doctorate degrees in astronomy from the University of Washington. In 1978, he was selected as an astronaut candidate, and had his first spaceflight aboard the Space Shuttle *Challenger* in 1984. He would also fly on the Space Shuttles *Columbia* in 1986 and *Discovery* in 1988. Pinky returned home to a hero's welcome for a visit to Willmar in 1989.

Three

WILLMAR PLAYS

Work can be exceptionally rewarding. However, unless it is balanced with enjoyment and relaxation, it can become taxing. On the early farms surrounding Willmar, games, pastimes, and even robust conversation were a means of enjoying life outside of work. It is true that the opportunities for play for the pioneers were far more limited than today's options, but they still knew that all work and no play makes for a dull life.

Over the decades, entertainment, like most everything, has changed dramatically. When Willmar became a city, there were no radios or televisions. Fun had to be had in a more primitive manner. An argument can be made that there are far more options for entertainment today than are good for people, and that is likely valid. There has been an interesting transition from when people had to take time to stop working for a bit of fun to now, when they must take time to stop having fun in order to work. Good old-fashioned fun means something completely different today than it did even five or ten years ago. It used to be that one had to be home at a certain day and time to watch an episode of a favorite show. Now, the internet allows binge watching of streaming digital entertainment whenever the mood strikes. It is important as a culture to place value on the entertainment of the past and not allow lives to become saturated with only modern definitions of the word.

Fortunately, the state and region provide many wonderful activities throughout the year. While personal preferences may differ, people are free to take a boat out on the lake for swimming, fishing, or simply cruising across the waves. They only have to go as far as Robbins Island or Sibley State Park to have a peaceful hike through the woods. For the hardier, activities such as snowshoeing or cross-country skiing can still give a thrill. Chapter three examines the history of Willmar's own brand of fun. Hopefully, it proves that reading about history is another activity that brings great enjoyment.

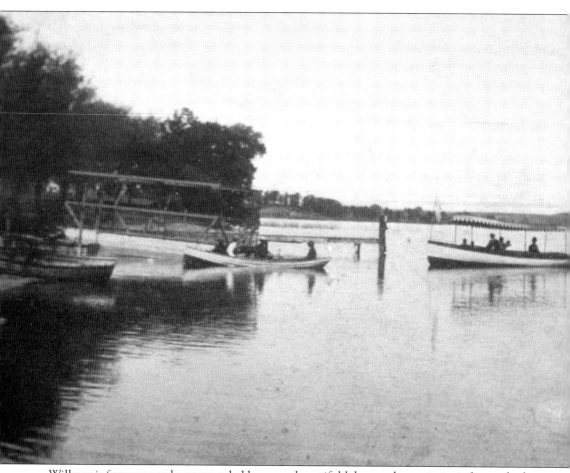

Willmar is fortunate to be surrounded by many beautiful lakes, and even in its infancy, the lure of the water captured the hearts of residents. This 1910 photograph shows the boat landing at Homewood Park on Foot Lake. A boat with several passengers is returning from a leisurely pleasure cruise around the lake.

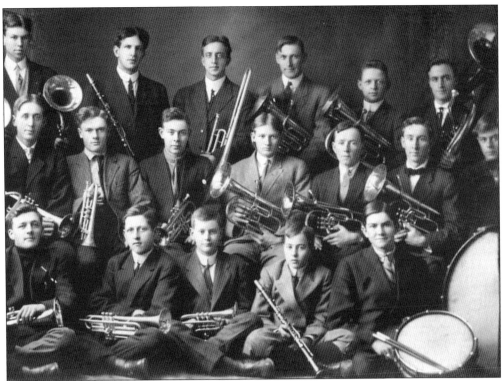

This photograph shows the Willmar Seminary Band on March 11, 1912. Willmar Seminary was incorporated as the Minnesota Lutheran Seminary and Institute in 1882.

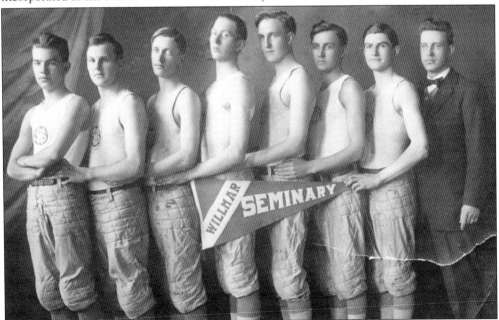

The Willmar Seminary basketball team is pictured here in 1914. From left to right, team members are Elmond Nelson, Obbie Nordstrom, Oscar Johnson, Kandy Johnson, Bill Gordhamer, Albin Kanikeberg, and Ray Christian. The coach is unidentified.

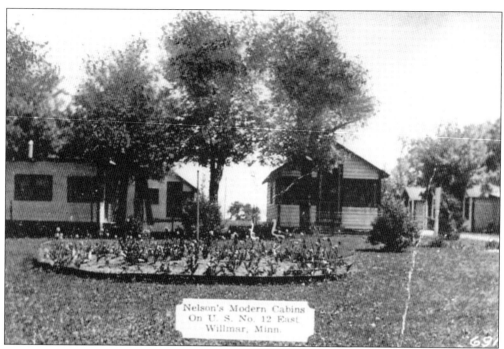

Nelson's Modern Cabins
On U. S. No. 12 East
Willmar, Minn.

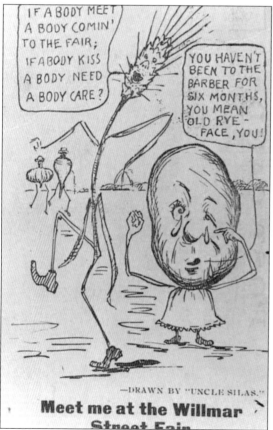

The tourist camp as a means of lodging was most popular between the 1930s and the 1960s. Willmar had a head start, as this photograph of Nelson's Modern Cabins from the 1910s demonstrates. The automobile was becoming attainable for average Americans, and they began using them to travel and vacation wherever the roads would lead them. Nelson's Modern Cabins was located on US 12 East.

Every community has its own interesting characters. For Willmar in the early 1900s, there was "Uncle Silas" Bluestem. In the August 25, 1909, *Willmar Tribune*, Uncle Silas is featured in an advertisement announcing him as the "Droll Artist-Philosopher who is Achieving Wide Fame." The *Tribune* collaborated with Silas to issue a set of eight comic postcards featuring his sayings and drawings. This postcard is an example of the very popular work of Willmar's version of Will Rogers.

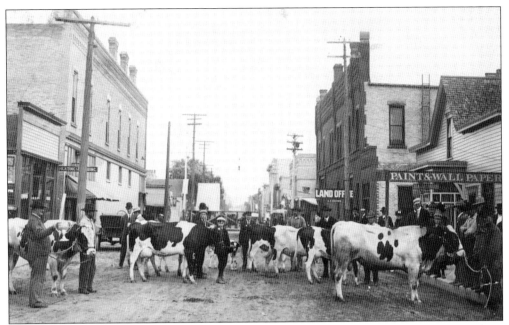

This early view of downtown Willmar from 1915 shows a traffic jam much different from those of today. Several head of cattle are led into the street by Willmar residents of widely varied ages. Visible in the photograph is the land office, a heating and plumbing business, and a store dedicated to paint and wallpaper.

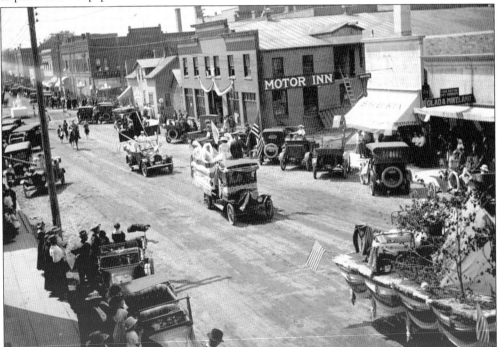

A Labor Day parade rolls through downtown Willmar in what is believed to be 1915. Automobiles are festooned with streamers, flags, and other decorations as Willmar residents line the streets. The Motor Inn at center was an early automotive garage.

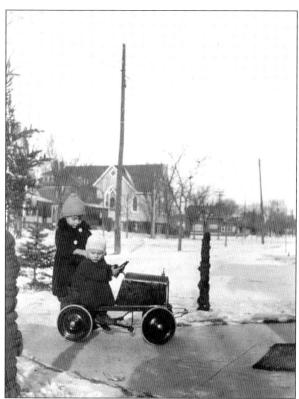

Cold and snow would not deter these hardy Willmar children from playing on their toy tractor in the winter of 1920. Like so many Willmar residents before and since, they took to the outdoors, braving the weather and engaging in some good clean fun. In the background is the old Methodist church that stood on the site of the current Willmar Post Office.

Long before NASCAR, auto racing swept the country. As soon as the automobile was developed, car manufacturers challenged each other to speed and cross-country races to prove whose invention was superior. This snapshot, taken in the 1920s, shows the Races at the Park. It was a popular event that often drew large crowds.

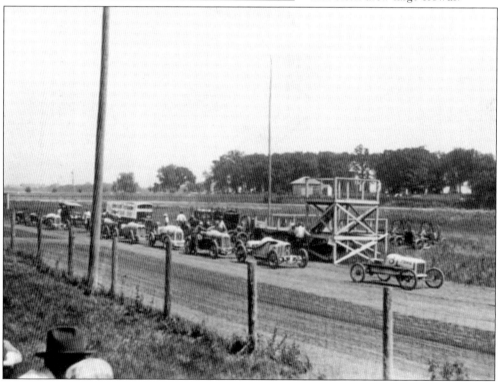

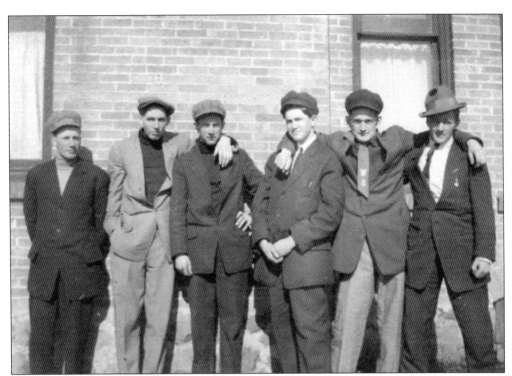

Many of the students at the Willmar Seminary engaged in various sporting pastimes. These handsome students, wearing an exceptional array of headwear and sport coats, were some of the institution's athletes. From left to right are Henry Dalen, Ablen Wallen, Rory Christian, Elmer Anderson, Albert Anderson, and Henry Abrahamson. The photograph is believed to have been taken in the early 1910s.

The great American pastime and the history of the nation evolved together as the decades passed. Abraham Lincoln was known to play pickup games. Soldiers on both sides of the Civil War used it to pass the time. Long before the Willmar Stingers came to town, baseball brought the people of Willmar together to enjoy a game. This 1920 photograph shows the grandstand filled with onlookers waiting for the next crack of the bat.

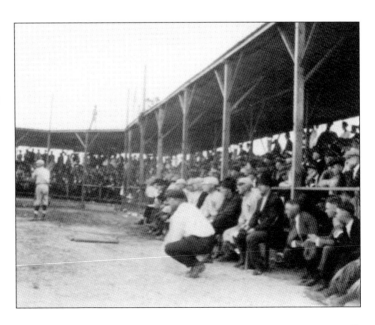

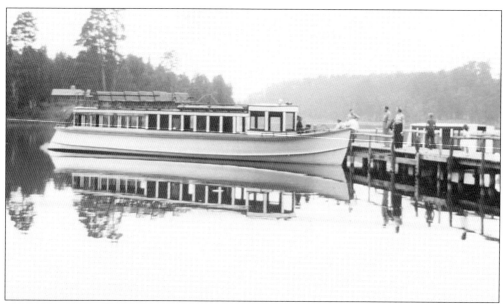

Louis S. Berg owned and operated a stately tourist boat on Willmar Lake. This 1926 photograph shows several tourists overlooking the boat from the dock. Willmar Lake was well known for its abundance of buffalo fish. In fact, the name Kandiyohi is a Dakota word consisting of *Kandi*, meaning "buffalo fish," and *ohi*, meaning "abounding in."

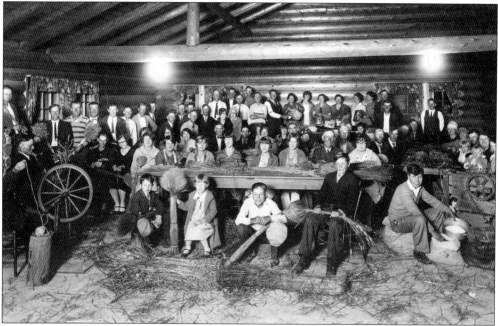

On the grounds of the Kandiyohi County Fair, a log cabin was built as a memorial to the pioneers who first settled here. The Kandiyohi County Historical Society operated a makeshift museum out of the cabin until it became an actual museum in 1963. It was soon clear that a larger space was needed, and the current museum was the result. The cabin was then donated to the people of Kandiyohi County. Every year at the county fair, historical exhibits are displayed in the cabin. This 1927 image shows locals preparing for a grain-stripping contest to be held at the Minnesota State Fair.

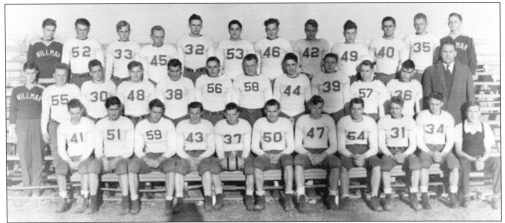

Football was a much-loved activity for both players and spectators at Willmar High School. The 1940 squad is, from left to right, (first row) Keith Johnson, Charles Bohanon, Wallace Anderson, Joel Dickson, captain Kenneth Bakken, Willam Buckley, Warren Erickson, George Anderson, Donald Langager, Charles Carlson, and Charles Martin; (second row) Jerome Scanlon, Wayne Forsberg, Robert Lorinser, Charles Reamer, Ralph Davis, Robert McGraw, Roger Hanson, Peter Newberg, Earl Samuelson, Bruce Gove, Donald Lawler, and coach Alvin "Nip" Teeter; (third row) Richard Osmundson, Robert Fenner, Jack Bloom, Charles Rosenquist, Jerome Larson, Robert Hodapp, James Rule, Douglas Langager, James Sigg, Harold Majerus, Roger Erickson, and Byron Elkjer.

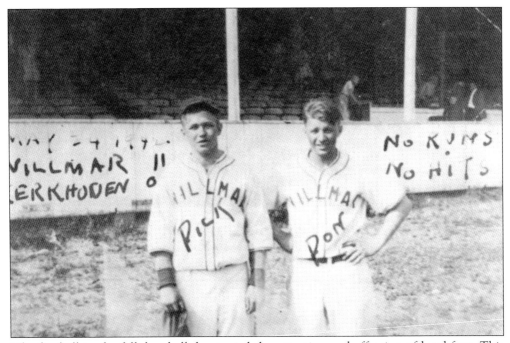

Like football in the fall, baseball dominated the attention and affection of local fans. This photograph, taken on May 24, 1942, shows pitcher Dick Selvig and catcher Don ? following a no-hitter over the Kerkhoven team, 11-0.

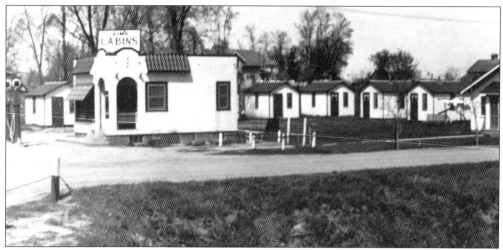

In 1942, the country was reeling following the attack on Pearl Harbor on December 7, 1941. America had entered the war, and approximately 16 million men and women would serve both overseas and here at home. Not surprisingly, many Americans took to the highways to take a break from the war. Tourist camps like this one became a welcome respite for weary travelers. Taken in 1942, the photograph shows Zim's Cabins, owned by Harold Zimmerman, at Willmar Avenue and Southwest First Street.

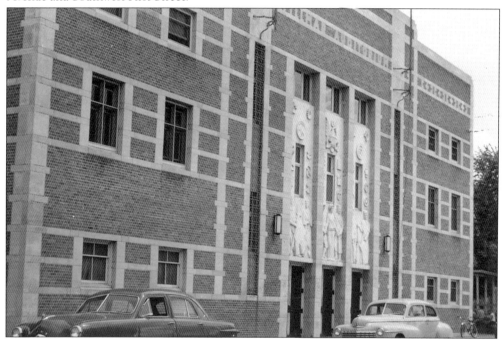

The Willmar War Memorial Auditorium, a WPA project, has long been a source of pride for the city. Construction began in March 1935, and the structure was completed in 1937 at a cost of $185,500. Inside, the War Memorial Room is dedicated to veterans of all wars. The room contains a stone from each state, including Alaska and Hawaii, which were added when they gained statehood. Many of the stones have a rich historical background. The sculptures above the doors were commissioned as part of the Federal Art Project, a New Deal program. This photograph was taken around 1945.

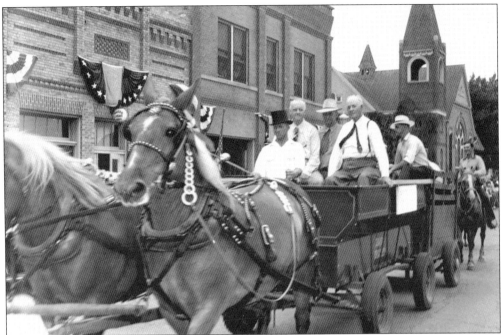

A team of sorrel Percheron horses owned and driven by William Schieder of Willmar travels down Litchfield Avenue as part of the Kaffe Fest Parade in 1948. Seated behind Schieder is chamber of commerce president Dr. B.J. Branton. Branton served as the grand marshal of the parade. Seated next to Branton is Martin Leaf, representing the city of Willmar. The others are unidentified. The horses are in front of city hall. The globe light underneath the patriotic bunting reads "Water and Light Department." In the distance, the Presbyterian church is also pictured.

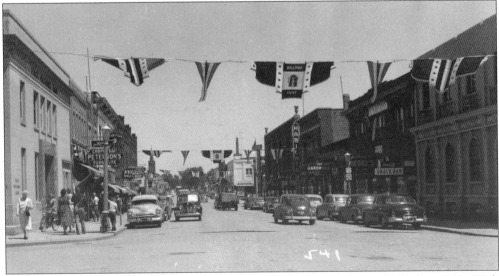

Festive banners are strung above Litchfield Avenue in honor of Kaffe Fest in the late 1940s. With the war over, cities across the nation celebrated with annual festivals such as Willmar's Kaffe Fest. Wonderful neon signage lines the street announcing businesses, including the First National Bank, Peterson's, Habicht's Hardware, and many others. At far right, the wonderfully decorated Tallman Building holds court over the street.

Local millionaire D.N. Tallman founded the Willmar Golf Club in 1931. His farm property was used to build a nine-hole course. This 1940s photograph shows a large group of spectators, likely attending the Lakeland Golf Tournament. Dave Tallman moved to Willmar in 1893 and began as a clerk for the Great Northern Railway. He married Gertrude Larson, the daughter of prominent banker Andrew Larson, and followed his father-in-law into banking. An ardent entrepreneur, Tallman dabbled in telephone, real estate, lumber, livestock, and other businesses. The 1920s took a toll on his wealth, but it did not get him down. Instead, he began golfing at age 50 and was eventually dubbed "Minnesota's Grand Old Man of Golf."

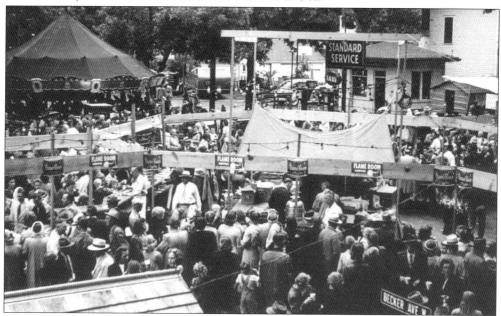

Kaffe Fest began following an early 1940s survey conducted by the *Willmar Tribune* that determined coffee consumption in Willmar was "astronomical." A group called the Willmar Saucer Drinking Society chose the Swedish word *kaffe* and organized the first Kaffe Fest in 1946. In its heyday, it was estimated that 15,000 to 20,000 cups of coffee were served during the event. This undated photograph shows the excellent turnout Kaffe Fest enjoyed.

This 1948 photograph shows a large crowd lining Litchfield Avenue for the Kaffe Fest Parade. It appears based on the umbrellas and wet-looking streets that rain was no match for the spirit of those attending. The Tallman Building, Bank of Willmar, city hall, and Presbyterian church are visible.

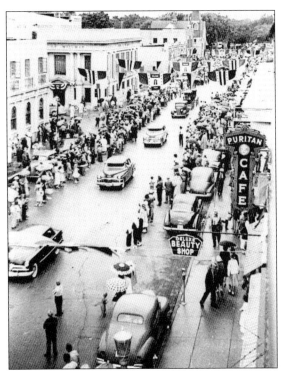

Despite the weather, large crowds of people lined up to see the Freedom Train, which stopped in Willmar on May 10, 1947. Following a decade of economic depression and a world war, the Freedom Train traveled the nation from 1947 to 1949 making stops in all 48 states. Within the train were numerous "documents of liberty" for viewing. President Truman, along with Attorney General Tom Clark, devised the idea in an effort to experience a "rededication" to the founding principles of the United States. In a single day, 10,787 Willmar residents viewed the exhibit.

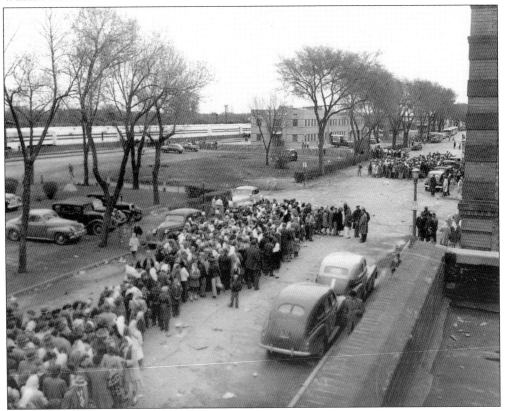

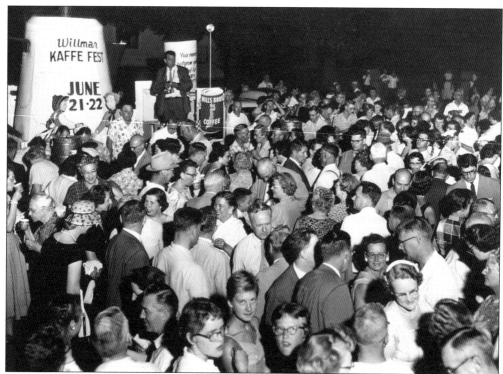

During Kaffe Fest, activities kept local residents entertained and caffeinated from morning until night. This large gathering of revelers enjoys their cups and their social interaction during one of the festival's events. It is safe to assume that many of them had a restless night.

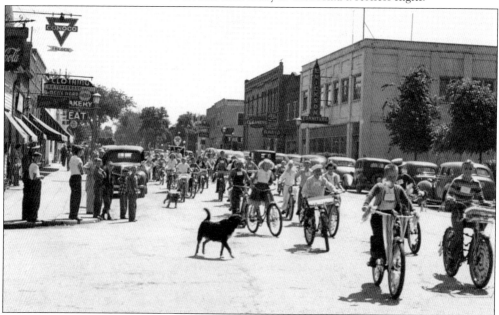

A kiddie parade in 1951 during Willmar's Kaffe Fest shows that fun was in store for residents of all ages. With bicycles lovingly decorated, the youths are riding down Litchfield Avenue displaying their handiwork.

This 1950 view of Litchfield Avenue shows cars advertising Paddy Nolan's Motor Maniacs. This was a thrill show in which Nolan and crew would perform various feats of daring in automobiles and on motorcycles. Patrons were entertained by watching cars crash through walls of fire, roll over, take high jumps, and even engage in a T-bone-type crash. Cars were typically provided by local automobile dealerships.

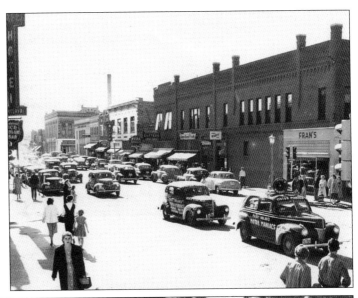

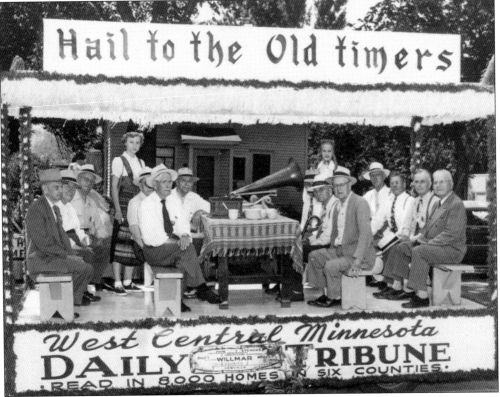

The *West Central Daily Tribune* used its 1950 Kaffe Fest Parade float to honor the old-timers of Willmar. Among the senior men, two unidentified girls wear traditional Scandinavian garb. Pictured are, from left to right, (first row) Sigurd Berkness, O.F. Gravgaard, and Judge T.O. Gilbert; (second row) Swan Anderson, Victor Lawson, and Andrew Nelson; (third row) attorney A.W. Stanford, Jens Olson, and Peter Hoglund; (fourth row) Dr. J.C. Jacobs, Carl Dahlheim, Andrew Ray, and unidentified.

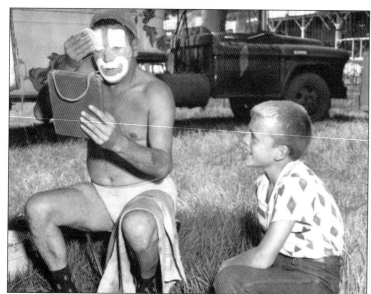

The Willmar Shrine Circus was another fun event that entertained and amazed adults and children alike. This *Willmar Tribune* photograph is dated August 1, 1957. A young man sits mesmerized by this clown painting his face in preparation for his act.

Arthur Werder Jr. shows off the first fish caught in the fishing contest that was part of Operation Snowflake Week in January 1957. Despite the miniscule size of his catch, Werder took home third prize, dedicated to the angler who managed to catch the first fish of the day. Based on the photograph, Werder had a great sense of humor. Operation Snowflake Week was sponsored by the Willmar Jaycees and offered numerous events to overcome cabin fever.

Christmas is a magical time, and Willmar has always been eager to celebrate the season. In this *Willmar Tribune* photograph taken in 1957, the camera captures city employees decorating a downtown light pole with a giant candy cane and garland.

One can almost feel the excitement in the air as professional wrestlers grapple with one another under the observant gaze of a referee. The photograph, taken during an event at the War Memorial Auditorium in 1957, shows the crowd watching intently with wide smiles as the wrestlers entertain. One interesting note is the no smoking sign above the leftmost wrestler's shoulder. Even in the 1950s, when smoking was permitted almost everywhere, Willmar cared enough about health to ban it in this public arena.

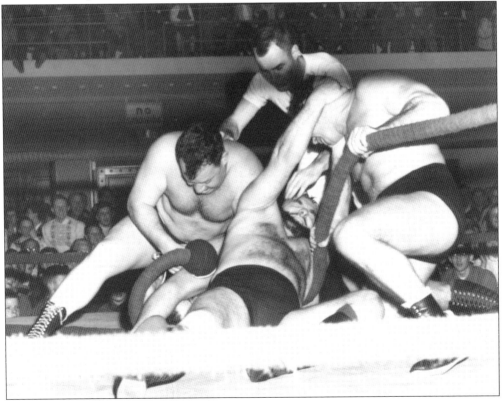

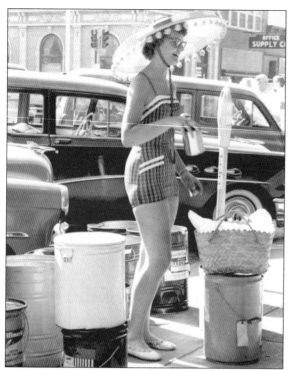

A Willmar woman clad in a bathing suit and a giant lampshade-like hat sells items on the street during one of Willmar's very first Krazy Daze promotions. Typically held in July, the promotion encouraged local businesses to place items on sale at "crazy" low prices to eliminate excess inventory, increase sales volume, and entertain the community. This photograph, taken at the corner of Fifth Street and Litchfield Avenue in 1957, is an excellent example of how those goals could be accomplished. Some local businesses continue this longstanding tradition today.

This 1958 Krazy Daze crew greets potential buyers in front of the Coast-to-Coast Hardware store in downtown Willmar. One can easily sense the light-hearted nature of the promotion. Those pictured are unidentified.

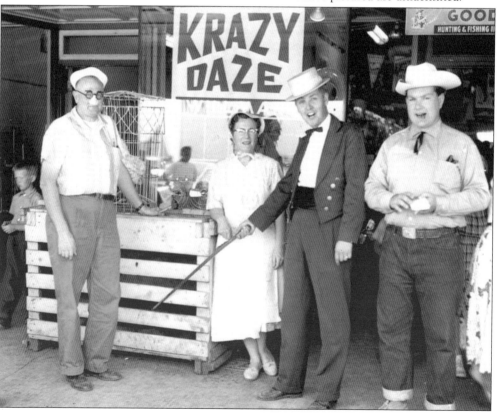

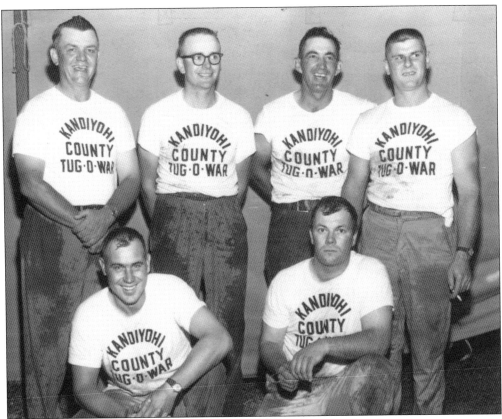

This proud group of unidentified men from Kandiyohi Township has their picture taken right after emerging victorious as tug-of-war champions during the 1958 Kandiyohi County Fair in Willmar. It is unknown what prize was awarded to the victors.

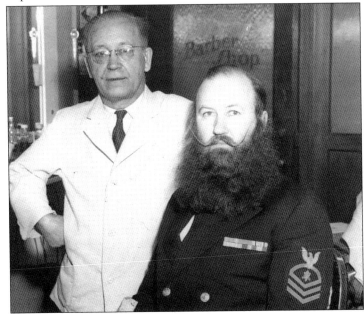

Julian P. Gudmundson of Willmar shows off the beard he grew while stationed in Little America, Antarctica, with the US Navy. The trip was part of Operation Deep Freeze, a code name for a series of missions to the icy continent. Upon his return in January 1958, Chief Builder Gudmundson awaits his barber, Frank Krasowski, to remove the beard and handlebar mustache he grew while on the faraway continent.

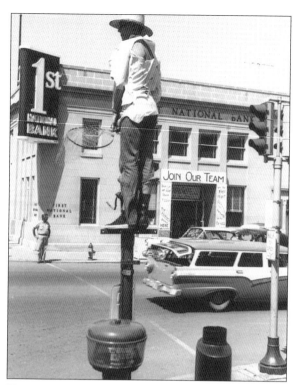

A young man stands atop a signpost at the corner of Fifth Street and Litchfield Avenue in the fall of 1959, armed with his wide-brimmed hat and a net. His escapade is in honor of the Turkey Days celebration. First National Bank stands in the background.

A camera snapped this shot of the main floor of the War Memorial Auditorium from the upper bleachers. The 1959 Auto Show is in full swing as local auto dealers mingle with would-be purchasers, tire-kickers, and other interested individuals. Numerous automobiles are present as well as signs clearly advertising Pontiac and Chevrolet.

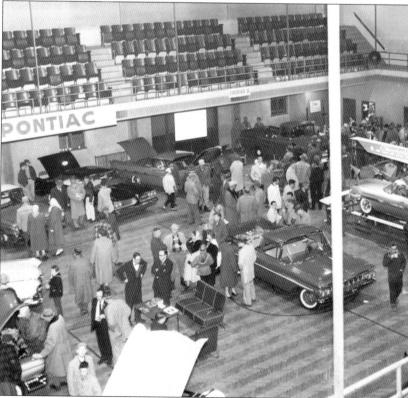

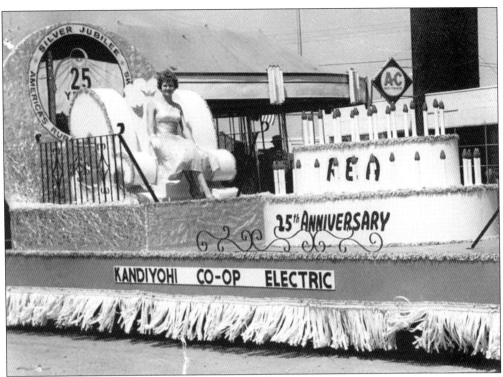

Kandiyohi Co-Op Electric celebrated its silver anniversary in 1960 with this lavishly decorated parade float. Organized in November 1939, its mission was to furnish, improve, and expand electric services to its members in west central Minnesota. Organization followed the Rural Electrification Act, signed by Pres. Franklin Roosevelt on May 11, 1935. Today, the cooperative continues to serve power needs under the name Kandiyohi Power Cooperative.

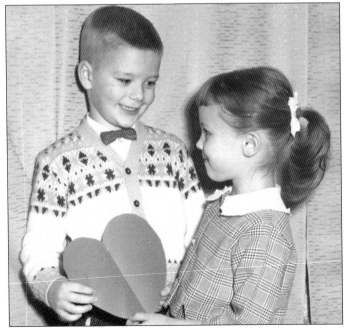

Cupid does not discriminate based on age. This young Willmar couple, Bruce Eastlund and Greta Sundberg, gets in the Valentine's Day spirit in February 1961. Both children, age five, demonstrate a Valentine's Day tradition and ask each other the question "Be my Valentine?"

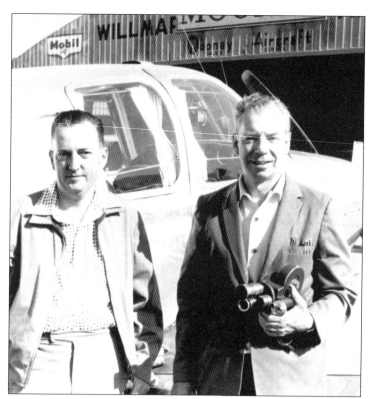

Sherm Booen, host of WCCO's *World of Aviation*, stands next to Wally Green of WCCO in front of the Willmar Municipal Airport hangar in May 1961. Booen was on hand to report on the Willmar Flight Breakfast for his program. Over 600 people attended the event, which featured pilots and over 200 planes. Weather was ideal for the fly-in and the breakfast, which lasted several hours. An estimated 500 people took rides during the event. The airport was established in 1934.

In an effort to show area residents the level of pride in the Boy Scouts organization, Ortis Bucher, the new executive of the Karishon District, secures a reflective banner on the vehicle of a district Scout. In March 1961, the Karishon District of the Boy Scouts planned to place one on the car of every Scout; It is not known whether they reached that goal.

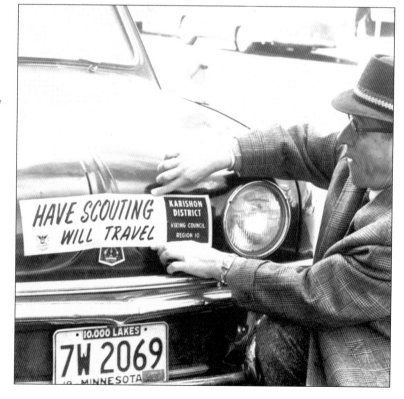

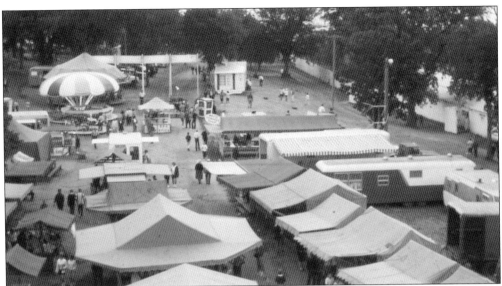

This is an aerial view of the 1964 Kandiyohi County Fair. The first fair in Kandiyohi County occurred in 1884, when an agricultural society was formed and a small building was built for exhibits. In 1901, the Willmar Street Fair and Harvest Festival began on Litchfield Avenue. As the population grew and the fair expanded, property was leased at the current Kandiyohi County Fairgrounds site, and a more traditional county fair was held there for the first time in 1912. Since those early days, residents have flocked to the parcel of land on the shores of Foot Lake.

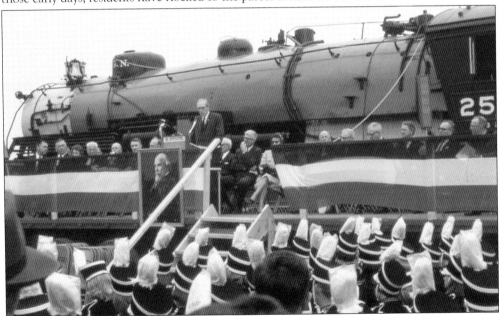

On October 17, 1965, Great Northern Engine 2523 was officially decommissioned and placed on permanent exhibit at the Kandiyohi County Historical Society. The steam engine was built in 1923 and was tasked with increasing the speed of passenger service through the mountains. It ran at 79 miles per hour and was painted the standard green present on all passenger trains. The engine was converted to an oil burner when it began service as a freight engine. Its final run was in 1958. Museum visitors are welcome to climb up and explore.

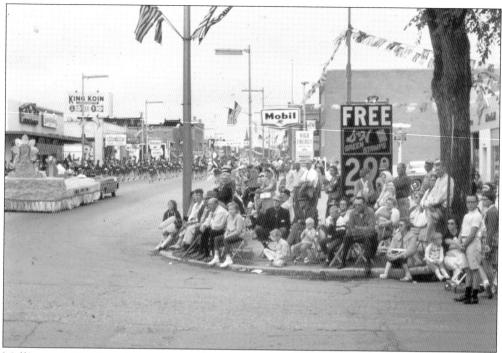

Miff Larson's Mobil station makes another appearance in this 1965 photograph of the Kaffe Fest parade. S&H Green Stamps were given out freely, and gas was 29.9¢ per gallon. A marching band can be seen underneath the billboard advertising the King Koin Launderette.

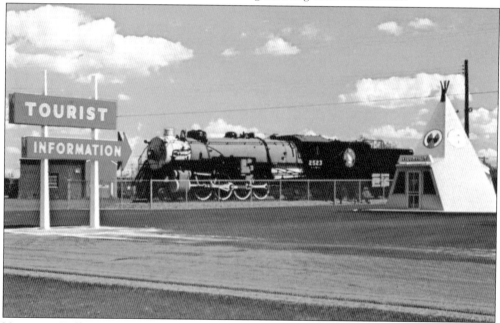

Visitors to Willmar in 1965 were greeted by the Kandiyohi Tourist Information Center, which was shaped like a teepee. Located on Highway 71 where the Kandiyohi County Historical Society now stands, it shows that not only did Willmar enjoy having fun, it also warmly welcomed those from outside the city to join in.

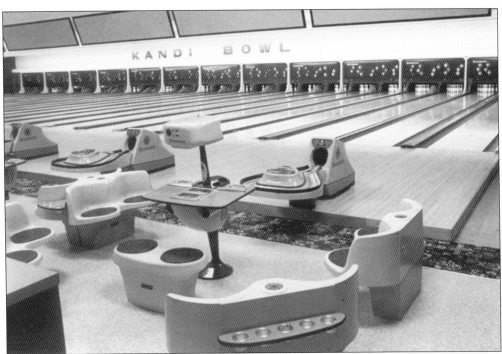

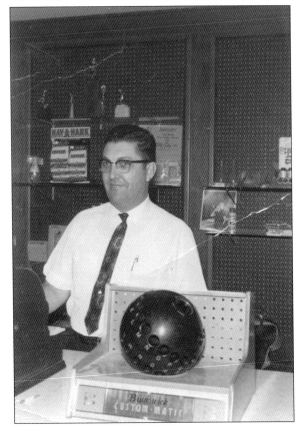

Orvis Pattison operated a bowling alley in downtown Willmar where the Kandiyohi County Office Building now stands. He operated the lanes there from 1960 to 1979, when he sold the operation to open the Kandi Entertainment Center (KEC). Along with bowling, the KEC complex was the first conference center in Willmar and had dining facilities and space for live music.

Orvis Pattison is seen in the 1960s staffing the counter at his downtown bowling alley. Pattison retired in 1998 and passed the business to his family, who continued to operate it. The KEC closed in 2017 with hopes that a buyer could be found to revitalize the enterprise.

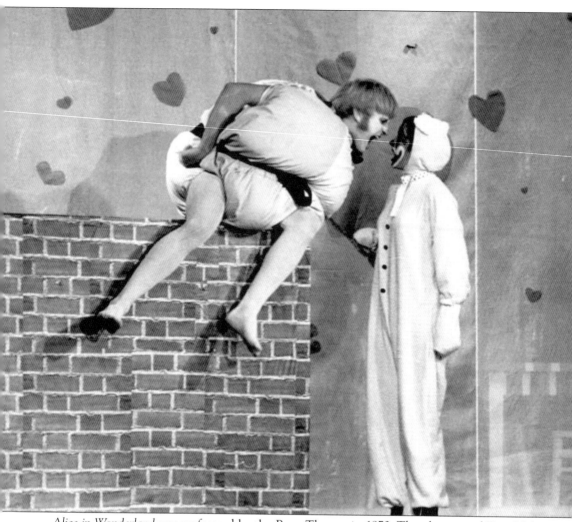

Alice in Wonderland was performed by the Barn Theatre in 1970. The play starred Don Mohs, Carol Thompson, Stacy Berg, and Gordy Cox. Officially incorporated as the Willmar Community Theatre, it is better known as the Barn Theatre. This is because when its volunteer-run board of directors purchased its first venue in 1964, it selected a vacant horse barn. The barn served the theater company until 1984, when required improvements were so extensive that a new venue had to be sought out. The Barn Theatre currently resides in its newly renovated space in downtown Willmar.

Four

WILLMAR SERVES

Willmar is and always has been a patriotic city. Duty to God and country is instilled within its citizens. The men and women of America's armed forces deserve sincere gratitude for the sacrifices they made to protect freedom. In an age of divisiveness, it can be easy to become jaded. The men and women who have served and continue to serve often go unrecognized in a culture in which the words "honor," "courage," and even "sacrifice" become watered down. They might only be celebrated on special occasions such as Independence Day, Veteran's Day, and Memorial Day. However, it is perhaps as important to acknowledge the service of veterans now as much or even more than any time in history.

Gratefulness to those in uniform can be shown in numerous ways. Willmar has several locations that memorialize America and the soldiers who protect it, including Willmar War Memorial Auditorium and Veteran's Memorial Park.

Service is not limited to the military. The fire and police departments keep citizens protected and safe from harm. The hospital and ambulance services provide assistance during medical emergencies. Community service organizations support residents. Even businesses such as the local newspaper and government entities such as the postal service serve the community. Whether one is a member of any of these organizations or simply enjoys a better standard of living because of them, they are worthy of admiration.

Chapter four is dedicated to all who serve their community in whatever capacity. Volumes could be written on them all, and this small collection of photographs and captions could never do them all justice. However, it is hoped that it will serve as a valuable reminder that without them, the people of Willmar would not have a thriving community to call home.

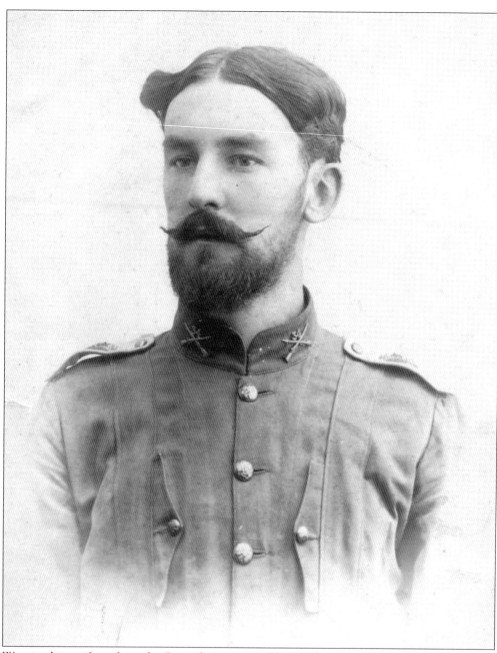

Wearing his uniform from the Spanish-American War, Cushman Rice is most likely pictured here during the Philippines Insurrection in 1898. The 15th Minnesota Volunteer Infantry, of which Rice and Sgt. John Frederick Mossberg were members, was organized and mustered into the service of the United States at St. Paul in July 1898. It consisted of 46 officers and 1,280 enlisted men. The men served first at Camp Meade, Pennsylvania, and then moved to Augusta, Georgia, in November 1898. The infantry mustered out of service in March 1899. Twenty enlisted men died of disease, and nine deserted. The unit did not see combat.

Sgt. John Frederick Mossberg was a member of Company D, 15th Minnesota Volunteer Infantry. He is shown standing near his tent in Augusta, Georgia, in 1898 while serving in the Spanish-American War. Mossberg was born in Illinois in 1874. Around 1887, he came to Willmar with his family. In 1895, he began working for the Northern Pacific Railroad. After the war, Mossberg returned to Willmar and continued his work with the railroad. He and his wife, Mary, had six children. A railroad accident took both his legs, at which point he began working in the superintendent's office. Mossberg passed away at age 73 in Illinois. Men and women from Willmar served in more capacities than the military alone. The below photograph, also from 1898, shows the Willmar Fire Department in a parade marching past the railroad depot. The fire department was established in 1879 as a paid-on-call department, which means firefighters are on call 24 hours a day.

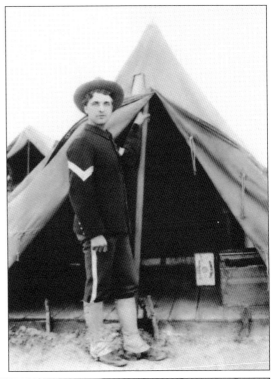

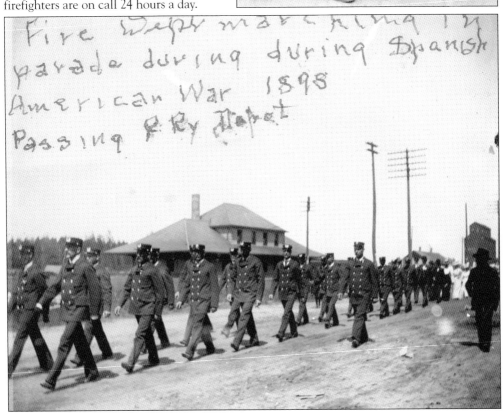

Fire Dept marching in parade during during Spanish American War 1898 Passing R Ry Depot

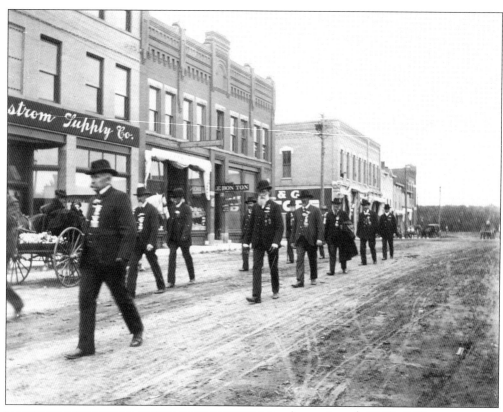

Approximately 12 Civil War veterans march in a Decoration Day parade, today known as Memorial Day, in 1905. They are marching down Fifth Street and passing the Fred Segerstrom Supply Company, located in the Ruble Block.

With World War I raging overseas, this hopeful-looking man leans out of his train car, presumably to watch his loved ones send him off to camp. More than four million troops served in the conflict, with over 120,000 killed in action. It is unknown if this soldier returned home to Willmar after his service.

Members of the American Red Cross march in a Willmar parade on May 17, 1918. The purpose of the parade was to inaugurate the second Red Cross War Fund Drive. Nearly 37 years before to the day, Clara Barton established the organization on May 21, 1881.

Cushman Rice was born in 1878 and passed away on September 4, 1932. Somewhat a soldier of fortune, Rice was a brigadier general in Honduras at the age of 18. He served as an officer in Cuba and the Philippines during the Spanish-American War. In China, he took part in the Boxer Rebellion. During World War I, he enlisted as a private and within four months earned the rank of major in the Army Air Corps. During the war, he was subjected to mustard gas. Rice spent five months in the hospital and barely survived. He traveled to Russia, Warsaw, and Odessa, where he convinced the counterrevolutionary Count Anatole Patapoff to come to Willmar and work with Rice's father, Albert, at the Bank of Willmar. He had an apartment in Havana, a cattle ranch, and a summer estate on Green Lake.

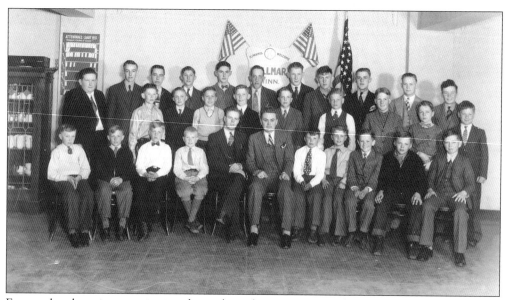

Fraternal and service organizations have always been active in Willmar. This photograph, taken in 1935, shows 31 members of the Willmar Kiwanis Club posing with a group of schoolboys. The Willmar Kiwanis Club was chartered in 1923.

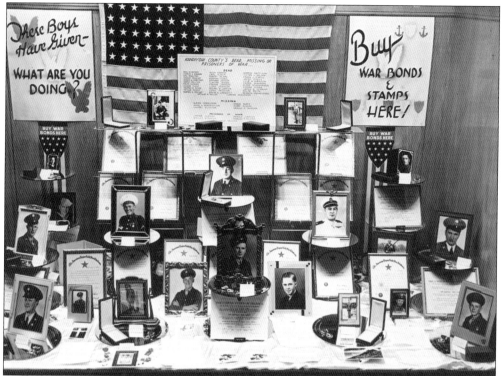

Like counties throughout the country, Kandiyohi lost a number of young men who sacrificed their lives for freedom. This photograph from the 1940s shows a display at the Willmar Woolworth's store during the Fifth War Loan Drive to sell war bonds. Photographs of deceased and missing soldiers as well as prisoners of war were featured.

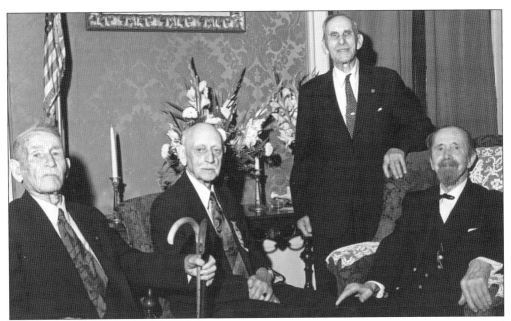

This photograph, taken on August 4, 1942, shows Andrew Larson (far right) celebrating his 102nd birthday at the home of David and Gertrude Tallman. Also attending are, from left to right, Nathan Colburn of Champlin, Minnesota; Orrin Pierce of Minneapolis; and William Lovell of Zimmerman, Minnesota. All four men were veterans of the Civil War. Tallman's home was known as the Tallman Mansion and was located on Ella Avenue.

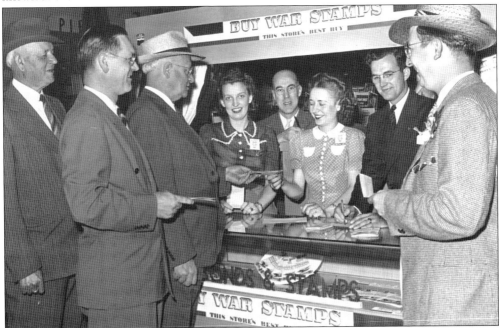

War savings stamps were issued by the US Treasury Department to help fund the country's participation during World War II. Two men and two women from Willmar sold war stamps from a booth in 1945. From left to right are Martin Leaf, Harold Lindell, T.O. Gilbert, unidentified, Dan Brennan, two unidentified, and Fran Osteraas.

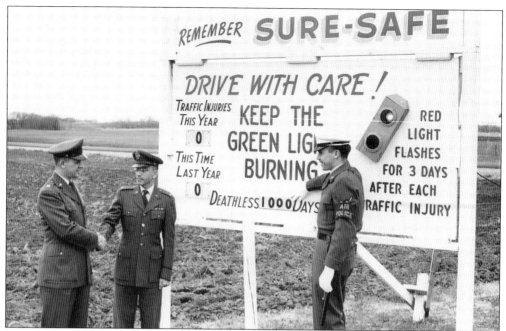

Many people are unaware that Willmar was once home to the Willmar Air Force Station. Located five miles northwest of Willmar, it was part of Phase II of the Air Defense Command Mobile Radar Program. The station opened on July 1, 1956. In February 1957, this photograph appeared in the *Willmar Tribune* with the headline "Willmar Air Base Begins Safety Program." Unidentified Air Force members are shown with a sign urging the community to drive with care. The station closed on June 1, 1961, due to budgetary constraints. Ridgewater College sits on the site today.

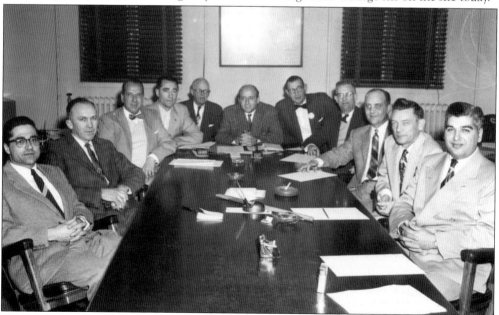

The newly elected Willmar City Council is pictured on January 8, 1957. Members include, from left to right, R.V. Hodapp, John Peterson, Oliver Leasure, Ervin Rau, city clerk Elmar Brogren, Mayor Seymour Grossman, city attorney L.M. Soderlund, Randall Johnson, Carl Hanson, and Peter Curtis.

The Street Flag Project of Willmar was sponsored by the Veterans of Foreign Wars and the American Legion with the goal of placing American flags along the city's streets. This photograph of nine members of the project was taken on April 23, 1957.

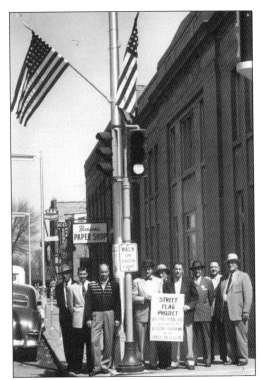

Civil defense programs were a product of the Council of National Defense, which was created by Congress in 1916 to assist in the protection of US citizens from military attacks and natural disasters, and consisted of principles including prevention, preparation, response, and evacuation procedures. Civil defense programs began across the nation during World Wars I and II, but became widespread under the threat of nuclear war. This *Willmar Tribune* photograph from September 12, 1957, shows members of Willmar's Civil Defense Corps examining an emergency radio. Signs identifying fallout shelters are still seen on many of the city's buildings.

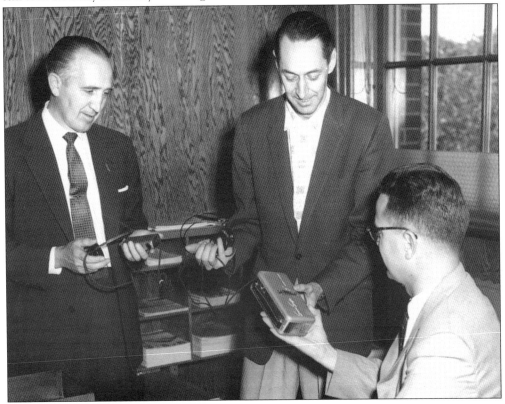

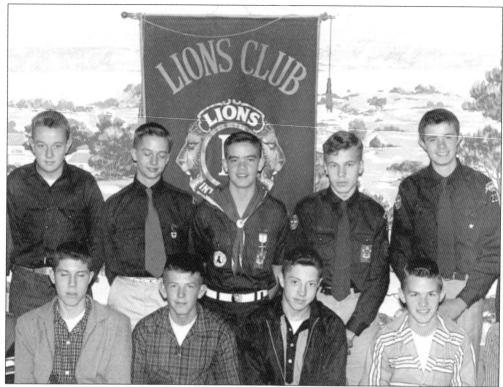

The Emergency Service Crew, a program of the Boy Scouts of America Explorers, allowed 14- to 18-year-old Scouts to learn the value of emergency professionals and assist them on service calls. The Emergency Service Crew of the Bethel Lutheran Church troop is seen at a Willmar Lion's Club meeting on October 11, 1957. The Explorers of the troop, a part of the Karishon Council, were making their first public appearance.

Mailing letters became a bit easier on April 14, 1958. Willmar's very first drive-up mailbox was put into service on the Litchfield Avenue side of the post office. Postmaster Olice Erickson delivers the first letter into the box. The new mailbox was touted as a great timesaver, allowing residents to post their mail without having to leave their car.

Wearing her Salvation Army uniform, Anna J. Olson rings the bell in 1958 for the Salvation Army Christmas kettle. Standing under the marquee of the Willmar Theatre, Olson was taking part in a tradition that began in 1891 and continues today. The Salvation Army began serving in Willmar in 1897. The movie playing at the theater that day was *Houseboat*, starring Cary Grant and Sophia Loren.

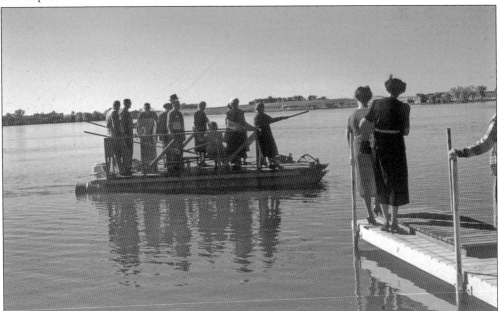

The Volunteer Council of the Willmar State Hospital watches on October 6, 1959, as the pontoon boat the group outfitted with a motor and safety equipment is launched on Willmar Lake. Their goal was to provide a means of rescue for accidents on the area's many lakes.

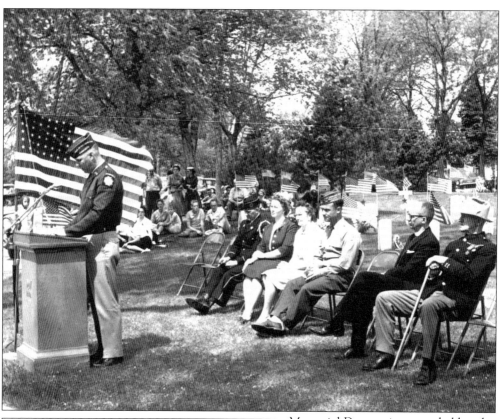

Memorial Day services were held at the Fairview Cemetery in May 1961. An address by Al Loehr, state junior vice commander of the Minnesota Veterans of Foreign Wars, speaks to the crowd, including representatives from each branch of the military and several Gold Star Mothers. Carl Freeburg, a veteran of the Spanish-American War, sits at right. A parade began the festivities and ended at the cemetery for a service that included an invocation, patriotic songs, and the address by Loehr.

Of the many groups and military organizations that serve a community, it should be noted that the local newspaper also serves. *West Central Daily Tribune* editor O.B. Auguston catches up on the latest work of his employees in this photograph, taken in the early 1960s. Not one to waste a moment, he multitasks by reading the news while sitting in his barber's chair.

Five

WILLMAR PRAYS

People of different nationalities often have their own traditions and religions. The faith of the early pioneers was incredibly important to them. When the town was in its infancy, churches were some of the first organizations to be formed. Because of the large number of Scandinavian immigrants in this area, the majority of the faiths were grounded in Lutheranism. Many jokes have been made about the culture surrounding the Lutheran pot-luck. However, it was no laughing matter to those who relied on their faith to help them survive the difficult times in life, of which there were many. Although the Lutherans had the largest numbers, they were not the only denomination in Willmar by a long shot.

Some were Methodist, others were Catholic. Some prayed with others, and some prayed alone. Groups met in homes, and others congregated in buildings erected specifically for their personal church family. As the years passed, some churches withered away, others grew exponentially, and some still serve the community today. Some churches merged, some built new buildings, and others merely upgraded the buildings they had.

The influx of different groups through the decades brought unfamiliar religions to the forefront. Because of this, it has always been important to go out of the way to communicate and dedicate oneself to understanding differing spiritual beliefs. The word "community" can be defined by stating that it stands for a group of individuals living and working in proximity to one another and sharing common attitudes, interests, and goals. Willmar has worked hard to truly embrace the community-minded attitudes and actions that prevent divisiveness and allow citizens to enjoy a friendlier and more respectful place to live.

Perhaps more than at any other time in Willmar's history, far different groups of people are becoming neighbors. Working closely and having community with people who are different can be challenging. Misunderstandings or simply a lack of knowledge about others' culture, language, and faith can be the cause of great frustration. Neighbors must overcome differences and greet each other with a warm smile and a friendly handshake—when they accomplish that, everyone wins.

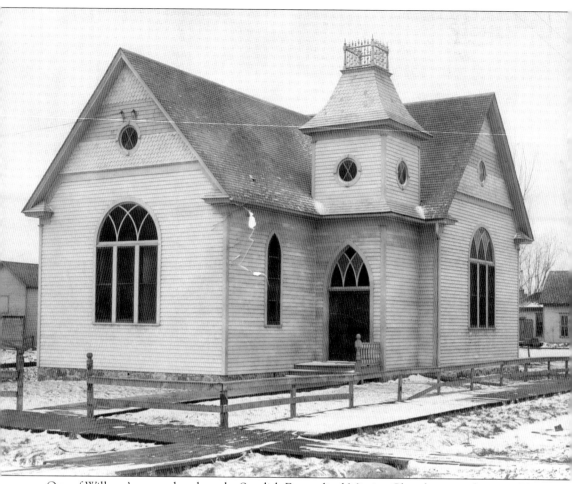

One of Willmar's many churches, the Swedish Evangelical Mission Church, is seen here in 1890. The church was formally organized on March 20, 1883. The church seen in the photograph was built in 1885. In 1958, the name was changed to First Covenant Church. It continues to serve today on Willmar Avenue Southwest.

Bethel Lutheran Church was organized on August 7, 1891. This 1900 photograph shows the first church building. It was on the corner of Becker Avenue West and Second Street South and featured a 75-foot-high steeple. In 1927, a massive new building was dedicated on the corner of Fourth Street and Becker Avenue, where it still stands today.

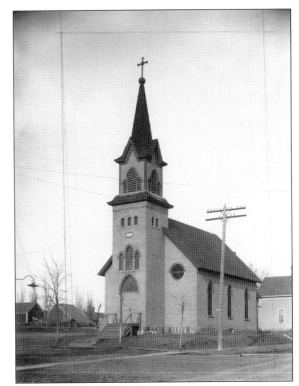

The interior of Bethel Lutheran Church's first building is shown in 1905. Note the Swedish words near the ceiling that translate to "Holiness Gentlemen Is Your House Adorning."

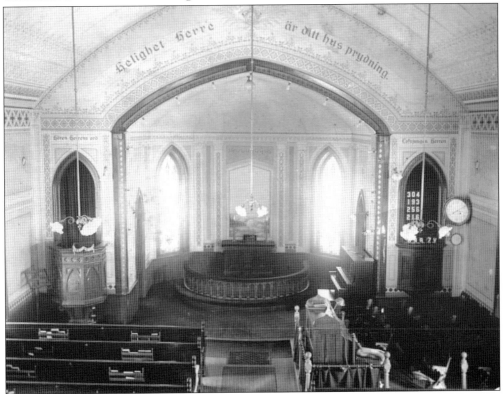

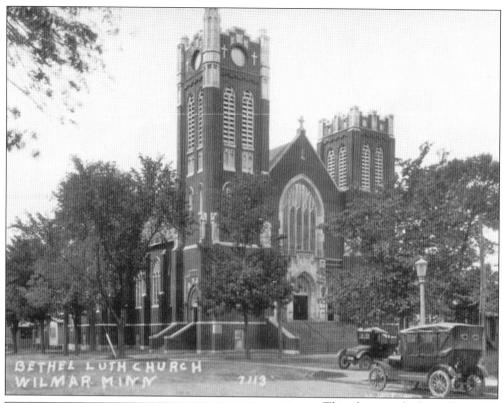

This photograph shows the new Bethel Lutheran Church, built in 1927, shortly after construction was complete. Located in the heart of downtown, the church has become the focal point of the downtown district.

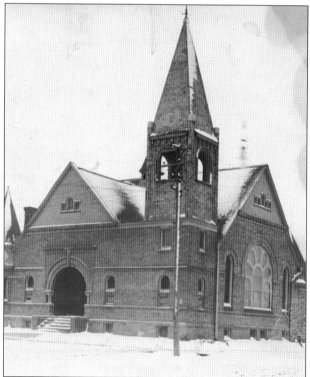

Ten members organized the First United Presbyterian Church in August 1870. A wood-frame building served as its home until 1893, when the brick church in this 1900 photograph was constructed on the corner of Litchfield Avenue and Sixth Street. A heavy storm blew the tower off, and an effort to pay off the debt left the building unfinished. It was officially dedicated in 1902. The church was destroyed by fire in 1947, and a new church was built on the site, which still serves the congregation.

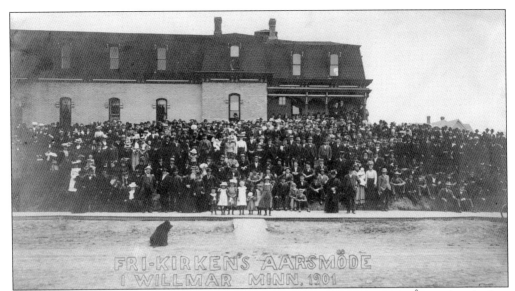

In 1901, the main building of Willmar Seminary was the site of Fri-Kirken's Årsmøde, which is Swedish for Free Church's Annual Meeting. An especially large crowd of Lutheran Free Church members poses as a large black dog watches them.

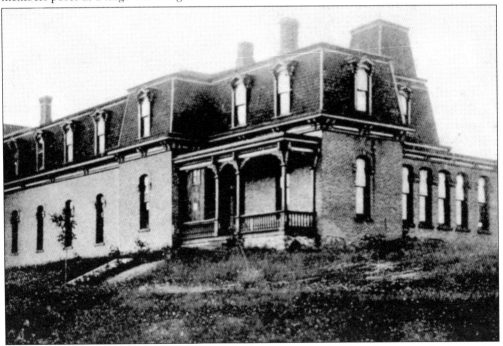

The main building of the Norwegian Lutheran Seminary, or Willmar Seminary, is pictured in the early 1900s. The school was incorporated in 1882, but a lack of funding kept it from opening until the following year. H.S. Hilliboe and A.M. Hove founded the school after meeting with local businesspeople. The final class graduated in 1919. The building was then purchased by the Lutheran Free Church, becoming a bible school that operated until 1929. The building was sold and demolished in 1931. Because of its location overlooking Foot Lake, a housing development sprang up in its place.

This group of 44 children was photographed in 1915 on the steps of a brick building that is possibly the first Bethel Lutheran Church. The Swedish Parochial School was a summer school that operated daily. Teacher C.B. Swanson stands at left.

The Norwegian Lutheran Free Church is pictured in 1916. The church in Willmar was the site of the Lutheran Free Church Annual Conference that year. The Lutheran Free Church was a denomination located primarily in Minnesota and Wisconsin from its inception in 1897 until it merged with the American Lutheran Church in 1963.

Rev. Harry Bovendam (left) reads a scripture passage as Rev. Clarence Van Heaklom (center), the pastor of a new Willmar congregation, and Peter Vos, representing the church extension committee of the Reformed Church, place the cornerstone on the church building. Bovendam was president of the Classis, Minnesota, congregation. The new church, Vista Lane Church, was on West Fifteenth Street. The building itself was a gift from the Roseland, Minnesota, Reformed Church. The church continues under the name of First Reformed Church.

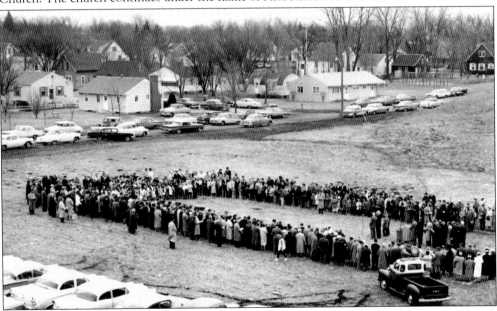

On a brisk morning in March 1961, approximately 500 parishioners of Calvary Lutheran Church were present for the ground-breaking ceremony of their new church. Pastor A.H. Sevig had the honor of turning the first shovel of dirt on the site adjoining the Bethesda Nursing Home in Willmar. The photograph was taken by a *Willmar Tribune* photographer perched on the roof of the nursing home.

Vinje Lutheran Church was organized in the fall of 1867 and incorporated in 1871. The first church building was made of logs in 1870. Four years later, it was decided that a new church building should be built on land donated by T.O. Feiring. That building was completed in 1875. In 1897, a move closer to the heart of the city was in the works, and a new church building was dedicated in 1906 on the corner of Becker Avenue and Fifth Street. That building served the congregation until a new church was dedicated in 1963 that continues serving its members today. This photograph shows the current building during construction in 1962.

Six

WILLMAR LEARNS

For thousands of years before Willmar was incorporated as a city, people across the world placed great value on education. Possessing knowledge allows one to examine the world as it is and creatively act in a manner that makes it better. An education matures and develops unique perspectives regarding life. It helps to determine and solidify personal values and is a necessary tool to form educated opinions on any subject. Understanding how things work engages people and allows them to improve. Because everyone faces change on a daily basis, an education assists in adapting as the world goes forward.

In 1870, when Willmar officially became a city, one of the vital institutions developed was a school district. By the following year, classes were being held offering pioneer children their first opportunity at a formal education. Soon there were many schools across town serving the different wards. The Willmar Seminary opened, providing an option for a secondary education. A college then began to provide a more specialized education. Even up to the present day, it is the primary role of the school board and other school officials to provide the greatest education possible.

The schoolteacher, professor, support staff, and administration are unsung heroes. Their passion is providing an education to their students. However, for most, teaching and serving students is so much more than just a job. They sacrifice their time, dedicate themselves to overseeing extracurriculars, and spend many nights grading papers and preparing lesson plans, all to selflessly help each and every student. Today, the teacher's role is no less important, but it is significantly more complex. In the effort to improve children's education, teachers have been forced to wear many different hats. They are educators, cheerleaders, social workers, politicians, and friends. They must be custodians, legal experts, security guards, and students themselves.

This chapter is dedicated in honor of all those who have worked or currently work in the field of education. Seldom do they receive widespread appreciation for all they do. They are satisfied with the small, daily victories that sustain them through both good times and bad. They most certainly deserve thanks.

This diorama, entitled "Spud Valley," was displayed at the Willmar Street Fair, sponsored by the Kandiyohi County Agricultural Society. The fair, in its fourth year, ran on September 12 and 13, 1887. The fair was a forerunner to the Kandiyohi County Fair celebrated today.

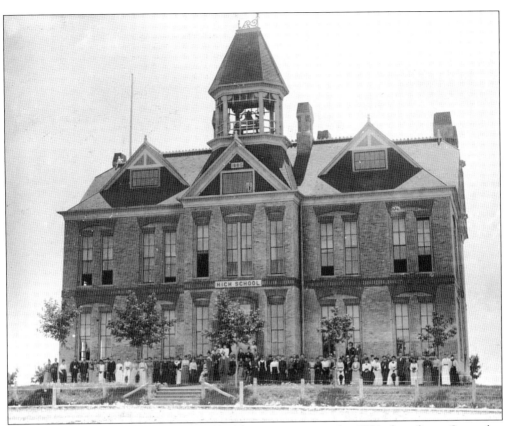

The second Willmar Central High School building was constructed in 1886 after a fire on September 18, 1885, burned the first high school. It was a total loss. A three-story brick structure was built to replace it, and that building is shown in the early 1900s. The large group in front of the school is attending a teachers' meeting. The school district was established in 1870. The first school term was taught in 1871 by Alma Willey. The first Willmar High School was built in 1881.

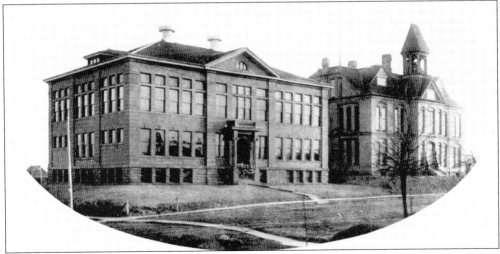

This postcard dating from the early 1910s shows the old Central School as well as the new Senior High School, which was located on the same grounds.

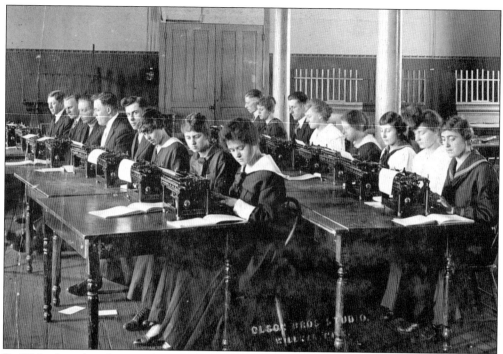

By 1915, when this photograph was taken of Willmar Seminary Business School students, typing was taught across the country. The photograph offers an inside look at the furnishings and interior graces of Willmar Seminary.

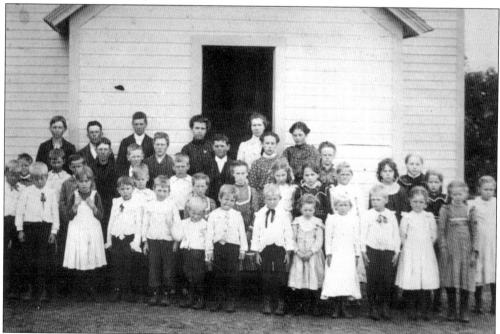

Students of Christine Elgeross are photographed with her in front of their schoolhouse in 1902. The varied age range of the children, as well as the overall look of the school, suggest that this was a one-room schoolhouse.

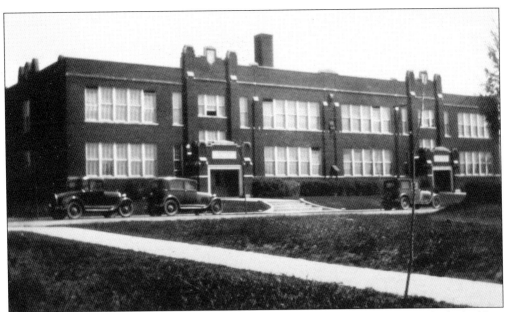

Lincoln Elementary School was constructed in 1924 and is pictured shortly afterward. The building originally served the students who lived in Ward Three. Growth in the student population in Willmar led to an addition to the school in 1957 and a second addition in 1965. The school closed in 2010. The building was put up for sale, but a lack of offers caused a discussion about demolishing the building. Fortunately, the building was finally sold, saving it from the wrecking ball.

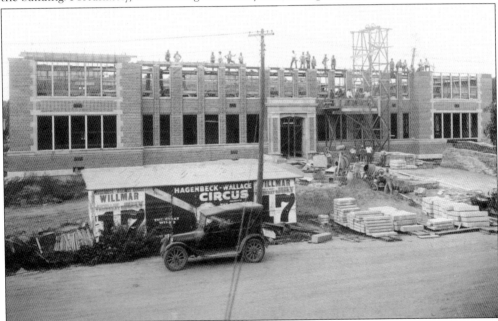

This 1930 photograph shows Garfield Elementary School under construction. The building was finished and opened in 1931. On Eight Street south of Trott Avenue, the school is now home to the Area Learning Center (ALC). The ALC provides an optional program that focuses on students who meet specific at-risk criteria. Note the advertising for the Hagenbeck-Wallace Circus in front of the building.

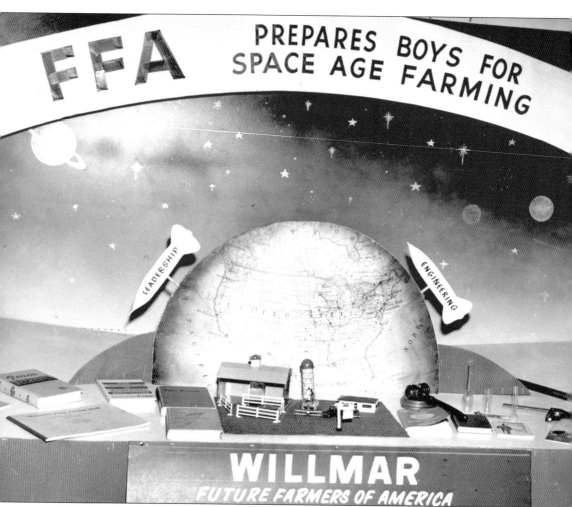

During National Future Farmers of America Week in March 1961, this booth was displayed in the Bank of Willmar. The booth, which won a merit award at the 1960 Minnesota State Fair, visually describes the importance of technological advances in the field of farming and the value of Future Farmers of America in preparing youth to embrace them.

Seven

WILLMAR SURVIVES

Survival in the wild and wooly days of the late 1800s to the mid-1900s was significantly more challenging than it is today. Hospitals knew nothing of sterility, and there were few vaccines available. While pharmacies did exist, many of the products sold for medicinal purposes caused more harm than good. In addition, medications were very basic, nothing like the vast range of scientifically tested drugs available now. There were no safety guards on tools and farm implements. Automobiles had dashboards made of solid steel with no airbags. Seatbelts were not even in existence until the 1940s, and they were not widely used by car manufacturers until the late 1950s.

In 1900, the life expectancy for males was 46.3 years. Women lived just slightly longer at 48.3 years. As of 2017, life expectancy for males is 79 years, and for women, it is 81 years. It may be hard for many to fathom the thought that they would be fortunate to live longer than what is today considered middle age. There were many reasons for this, as listed above. Usually only the strong or the lucky survived into their 80s, 90s, or 100s. There was, however, a third variable, and that was the indomitable spirit that allowed one, no matter the circumstance, to press on and overcome.

The luxuries and protections of the modern day are often taken for granted. From indoor plumbing to central air-conditioning and refrigeration to insulated homes, modern life is in many ways a charmed one. However, many people have even more dangers and disasters to face today. Fortunately, people today come from a long line of hardy souls and their grand inheritance is a similar spirit. Willmar has faced fires, floods, tornados, epidemics, wars, blizzards, explosions, train wrecks, grasshopper plagues, and countless other calamities since its founding. Yet as a community, together it forges ahead, just as its ancestors and their ancestors have done since the dawn of time.

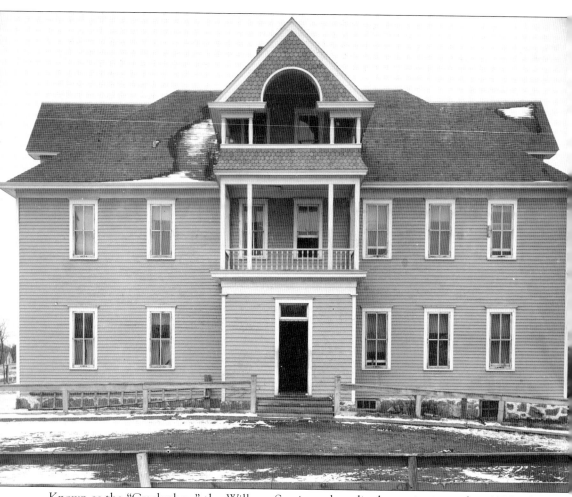

Known as the "Crackerbox," the Willmar Seminary boardinghouse is pictured in 1885. The building was at 716 Olaf Avenue, across Foot Lake from Robbins Island. It provided a warm place to stay for Willmar Seminary students who attended the school.

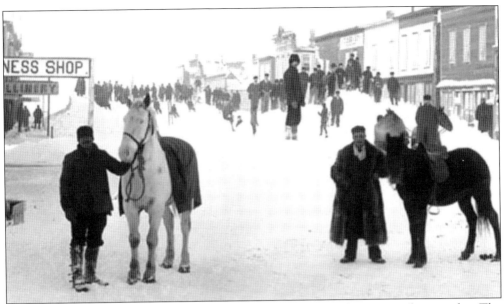

On January 12, 1888, Willmar residents awoke to a surprisingly warm and sunny day. The temperature encouraged people to head outside, unaware that they were about to face a deadly blizzard that struck rapidly and violently. Temperatures dropped from above freezing to approximately 40 below zero. Winds pelted the faces of those caught outside with icy flakes. It was known as the "Children's Blizzard" because the storm struck just as many schoolchildren in its path were walking home for the day. It is estimated that between the Dakotas and Minnesota, 250 individuals died during the blizzard, some of whom were not found until the spring. Others died later as a result of pneumonia and infection from amputations. Overall, the blizzard was directly responsible for over 500 deaths. This January 13 photograph provides a glimpse of the storm's aftermath.

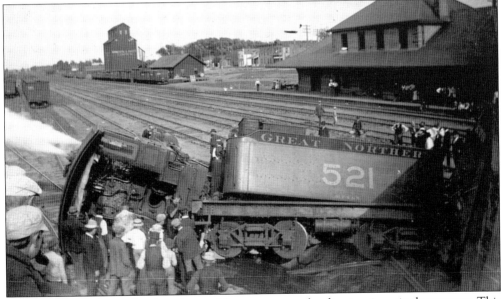

Great dangers associated with trains could cause spectacular disasters in a single moment. This 1900 photograph shows Great Northern Engine 521 shortly after it derailed in front of the Willmar Depot. Note the steam still pouring out of the stacks.

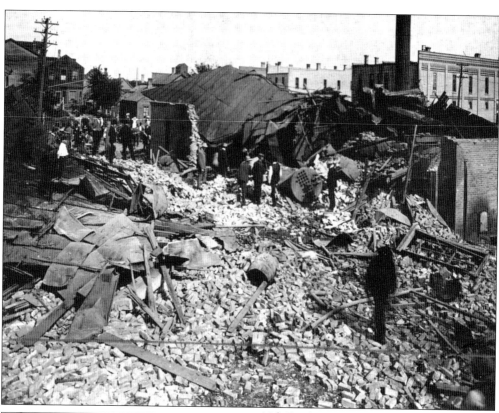

A Narrow Escape.

An accident happened to Postmaster Birch and family last Sunday afternoon which luckily did not prove serious. They were driving along East Becker avenue, and when near the Parkins residence the horse stumbled over a piece of board lying on the street. The spot happened to be a rather steep incline and the fall of the horse resulted in throwing Gladys over the dashboard, but she was soon rescued by her father. In the excitement of the moment Mrs. Birch got her foot entangled in the wheel, and received a severe wrenching. Mr. Birch managed to prevent the rig from further progress and extricated his wife from her perilous position. The harness was demolished as well as part of the buggy. A nearby rig lent assistance and took the unfortunates home. Mrs. Birch's injuries, though not serious, proved very painful, and the party was lucky to escape as it did.

Nils Bredeson, an employee of the Willmar Municipal Plant, went to work on September 22, 1901, thinking it was just an average day. Bredeson was the only employee at the plant when one of the boilers exploded, completely demolishing the building. A portion of the firebox was launched through the air, landing near the courthouse. In addition, the 75-foot-tall chimney fell. Bredeson was blown clear of the building and knocked unconscious by the blast but miraculously survived. The plant was later rebuilt at the same location.

This article, published in the *Willmar Tribune* on April 24, 1901, is just one example of many demonstrating that accidents were commonplace and could befall anyone at any time. The article explains how a family Sunday drive could lead to a very narrow escape. Fortunately for Postmaster Charles A. Birch's wife, Gladys, her husband's quick thinking and help from a neighbor saved the day.

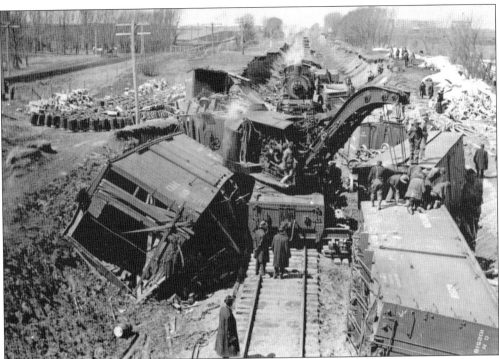

This photograph captures the scene of a train accident near Willmar around 1905. A large crane works to extricate the demolished boxcars to allow an oncoming train to pass.

The Bethesda Hospital was brand new when this photograph was taken in 1911. At 322 Second Street South, the hospital was one of several operating in Willmar despite it being a small community at the time. The Bethesda Hospital was not affiliated with the Bethesda Children's Home or the Bethesda Nursing Home, now called Bethesda Health and Housing.

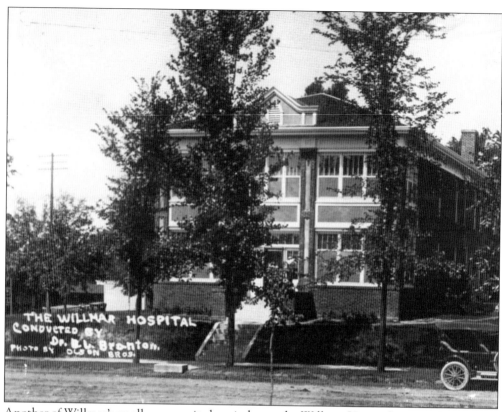

Another of Willmar's small community hospitals was the Willmar Hospital, operated by Dr. B.J. Branton. This, the largest of the early hospitals, was built in 1907 at the corner of Fourth Street and Becker Avenue. The hospital was in operation until the completion of Rice Memorial Hospital in 1937. Branton also founded the Willmar Clinic in 1920. The clinic moved into a new building in 1970. It is now known as the ACMC Clinic on First Street and Willmar Avenue.

This April 1940 photograph shows the aftermath of a boiler explosion at the Great Northern roundhouse. The explosion, which was caused by low water, blew Alex Gustafson into the coal bin. The boiler was hurled through the roof, and bricks were found thrown as far as Litchfield Avenue. Gustafson suffered from shock, but fortunately was not seriously injured.

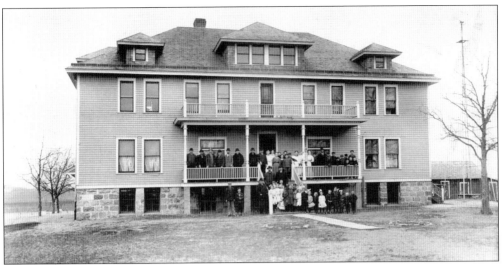

Bethesda Children's Home began when Pastor Nils Heggerniss of Lamberton, Minnesota, welcomed three young children into his home after he learned that their alcoholic father was abusing them. By 1905, the building constructed to house the children had proven too small, and the organization was moved to Willmar. Bethesda Home was built in 1905. In 1910, an additional home was built for the elderly. The children's home ceased operations in 1939, when state law introduced the foster home system. This photograph is believed to have been taken shortly after construction.

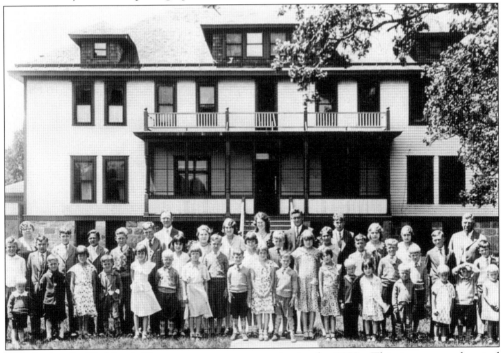

The Bethesda Children's Home appears near capacity in the 1930s. This image was donated to the Kandiyohi County Historical Society by Diane Carlson, whose father, Severin Roland Carlson, and his younger brother Calvin and younger sister Norma were raised there after their father, Severin Carlson, died at the age of 33 of a brain tumor. His mother, Alma Nelson Carlson, brought them to Bethesda Homes and was a cook there.

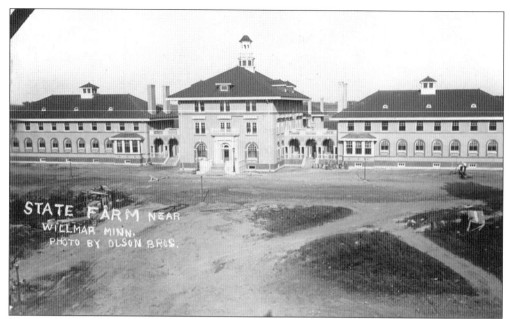

Described as the "State Farm near Willmar Minn.," this photograph depicts the main building shortly after construction in 1912. The site was chosen on land known as the Tallman farm, owned by local businessperson D.N. Tallman. It was also land that was once occupied by Solomon Foot, a pioneer feared by the Native Americans, who considered him the greatest marksman of all the early settlers. The hospital grew much larger by the time it closed in 2002, when it was purchased to become the MinnWest Technology Campus.

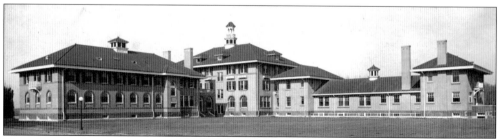

This photograph shows the main building of the Willmar State Hospital during the 1920s.

Dr. Benson's Hospital advertised in this postcard that it was "Fireproof and Modern." The hospital is seen here as it was in the 1910s. It was at 817 Fifth Street in Willmar. I.S. Benson, along with Dr. N.R. Sandven and Dr. Ernest Gillmore, operated this small medical facility alongside several other community hospitals in the early 1900s.

Willmar's first fire station shared a building with city hall and the Willmar Power Plant, as shown in this early 1900s image. At the time, the firefighting equipment was pulled by horses and was better for containing fires to a single building than saving the building in which the fire began.

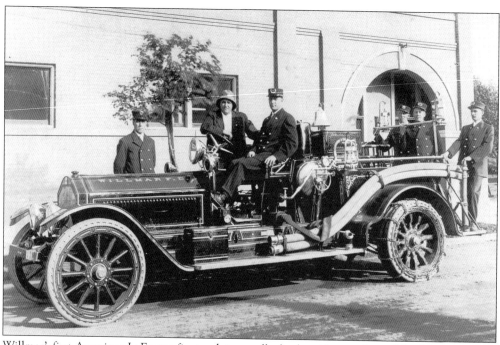

Willmar's first American LaFrance fire truck is proudly displayed by members of the fire department in 1920. The truck was purchased by the department in 1917 to replace a smaller fire truck purchased in 1913. The fire station behind them was at Sixth Street and Litchfield Avenue. It was demolished in 1970, when construction on the current Willmar Fire Station was completed.

In 1917, US representative Andrew Volstead authored the Volstead Act, which prohibited the production, sale, and transport of intoxicating liquors. This 1925 photograph shows confiscated liquor and moonshine equipment on display outside the Kandiyohi County Courthouse. The Volstead Act created strong dividing lines between temperance groups and prohibition reformers. Prohibition was repealed on December 5, 1933.

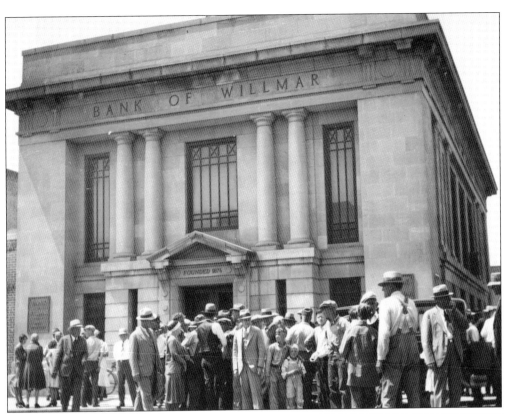

On July 15, 1930, the Bank of Willmar was the target of a group of five bandits brandishing revolvers and machine guns who managed to make off with over $100,000. The street erupted in gunfire as Sam Evans, "Jolly" Pearson, and R.S. Paffrath shot at the bandits. All five men escaped, but it is believed that two were wounded, perhaps one fatally. It is not certain who the bandits were, nor was any of the cash, gold, or bonds ever recovered. Two local women and a young boy were injured during the ordeal. Marks from the bullets can still be found on the Tallman Building. On June 21, 1995, the robbery was reenacted by Willmar residents at First American Bank in the same intersection, Fifth Street and Litchfield Avenue, where the robbery occurred some 65 years earlier. A large crowd gathered to witness the event.

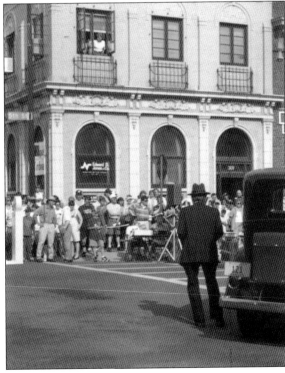

Family was just as important to Willmar residents in the early days of the city as it is today. Willmar is fortunate to be an exceptionally neighborly town to live in. People help one another, civic organizations help to meet unmet needs, and churches are benevolent. However, the bond between members of a family can conquer all. This photograph of the Hjort family in 1926 displays that bond. Cecelia (Edmund) Hjort would call husband Niels to the dinner table by announcing, "Niels, Niels, come now or I will take the table off." The family immigrated to Willmar from Schleswig-Holstein, Germany.

Death can come at any age. Unfortunately, for the Willmar class of 1938, a number of classmates were met by it long before their time. Three members of the class stand next to a sign hanging as a memorial to the nine classmates who passed away before graduation.

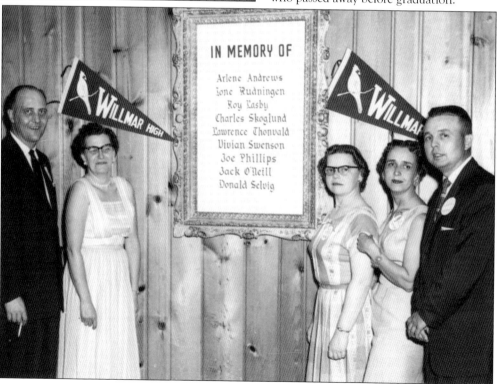

IN MEMORY OF

Arlene Andrews
Ione Rudningen
Roy Lasby
Charles Skoglund
Lawrence Thonvald
Vivian Swenson
Joe Phillips
Jack O'Neill
Donald Selvig

On June 10, 1947, a tornado struck Willmar, causing significant damage to the dairy and horse barns at the Willmar State Hospital. One of the buildings collapsed, while the other suffered damage to the roof. Through the years, numerous tornados have been spotted in and around Willmar. While many caused little damage, others have taken a toll.

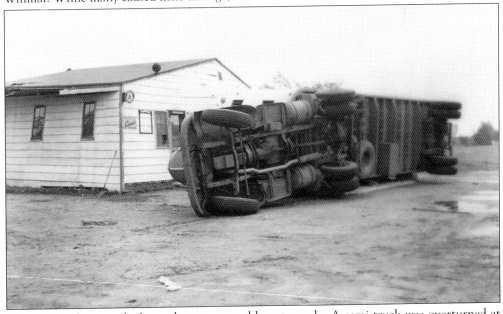

This 1940s photograph shows damage caused by a tornado. A semi truck was overturned at Anderson Cabin Camp near Willmar. At the time, there were no tornado warnings available. It was not until the late 1940s that two Air Force officers identified conditions favorable for tornados. The first tornado warning was issued on March 20, 1948, in Oklahoma. It was not until well into the 1950s that tornado warnings would become widespread.

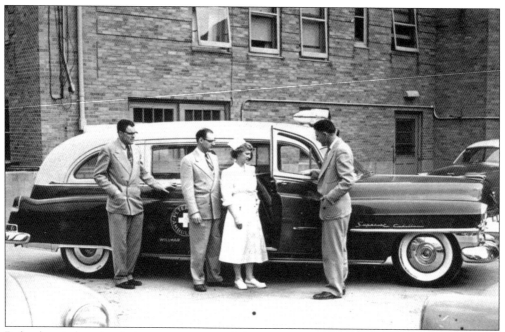

Before hospitals and ambulance services provided onsite emergency medical care and transportation, funeral homes served in that capacity. The Peterson Brothers Funeral Home ambulance is pictured in 1955. It was primarily used to transport polio victims to the Twin Cities for care.

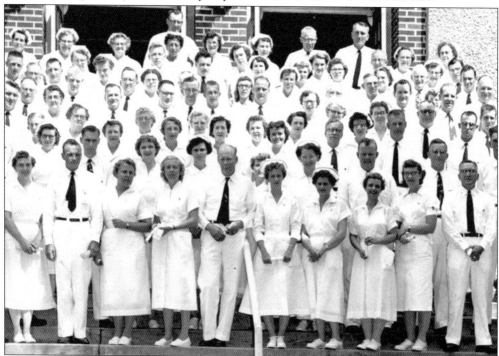

As medical knowledge grew, the role of doctors and nurses in the care and survival of their patients became increasingly important. In August 1957, the Willmar State Hospital recognized 97 aid employees, some of whom are pictured here, for their service.

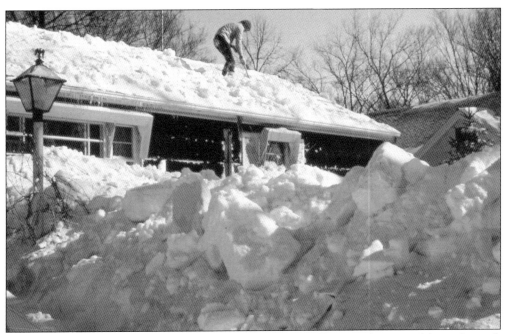

On St. Patrick's Day 1965, it was exceptionally difficult for Willmar residents to celebrate. Instead, the St. Patrick's Day Blizzard blanketed the city. The amount of blowing snow that was deposited can be seen in this photograph from the day after, as a local works to prevent damage to his roof by shoveling the snow that had fallen on it.

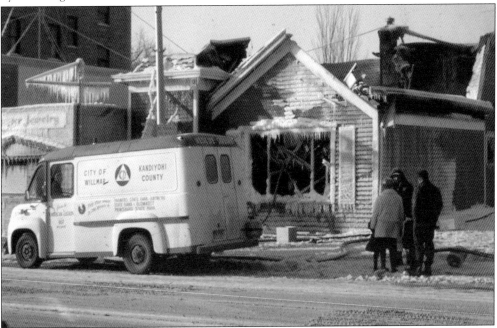

The Lowell Inn Café was destroyed by fire in January 1968. Though the Willmar Fire Department fought the blaze valiantly, the establishment was a total loss. Fortunately, there were no injuries because of the fire. A civil defense vehicle is on site as passersby discuss the scene. Langager Jewelry adjoins the Lowell Inn restaurant.

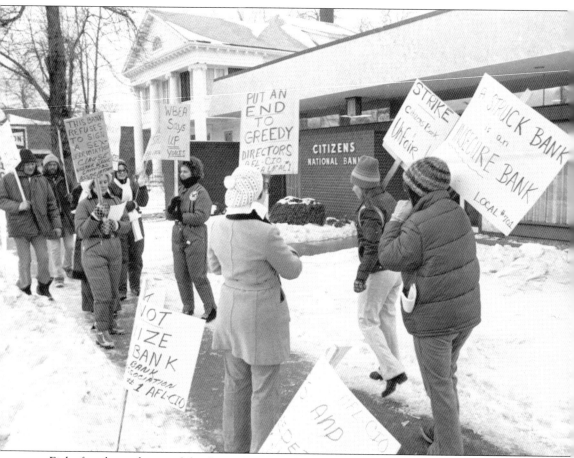

Eight female employees of the Citizen's National Bank in Willmar went on strike on December 16, 1977. Doris Boshart, Irene Wallin, Sylvia Erickson Koll, Jane Harguth Groothuis, Sandi Treml, Teren Novotny, Shirley Solyntjes, and Glennis Ter Wisscha would become known as the "Willmar Eight." The event was divisive, and few showed any support for the women. Striking on the grounds of sexual discrimination, the women felt that they were subject to unequal pay and unequal opportunities for advancement. In 1979, the National Labor Relations Board ruled that the bank was in fact guilty of unfair labor practices. However, the board did not feel that those practices were the cause for the strike; rather, it determined that the cause was economic, and there would be no back pay, nor a guarantee that the women could resume their jobs. During the strike, the eight women held the picket line when the wind chill was 70 degrees below zero.

Eight

WILLMAR LOOKS AHEAD

Up to this point, the focus has been on the past of Willmar, a beautiful city in west central Minnesota. The journey has borne witness to the past lives of citizens. Although the final chapter is titled "Willmar Looks Ahead," the images contained here are all from the past. However, they were specifically chosen to show that throughout the town's history, members of the community dared to dream, to plan, and to execute those dreams and plans using only the means available to them at the time.

All have a responsibility to their children, grandchildren, and all descendants down the line. This book is filled with photographs. They are a snapshot of everyday moments that today are looked upon with reverence and appreciation. On the whole, these moments captured in time are infinitesimally smaller than all the moments that could have been and perhaps deserved to be captured. It is for this reason that they are priceless. Imagine that decades from now, people who live in a completely different world may gaze upon today's moments, captured in time, and have the same appreciation and reverence.

Their value is multifaceted. They warm the heart. They are interesting, humorous, and beautiful. They take viewers back to the halcyon days of their childhoods. They connect residents with their town and the people who lived here in a meaningful way. They are emotional and tender. They are also educators. Through them one learns what life was like, understands the mistakes that were made, and gains the knowledge to prevent them from happening again. They provide a sense of pride, not only of those people known personally long ago but also those never met.

History is important. The beauty of community is joining together to serve one another, using each other's interests and talents to better the community as a whole. May Willmar continue to thrive.

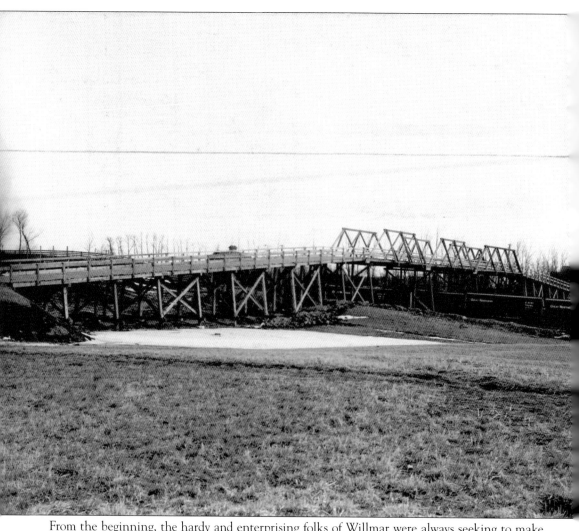

From the beginning, the hardy and enterprising folks of Willmar were always seeking to make things better and to advance as a community, and had great hope in the future. This is evidenced in this photograph from 1900 that shows the wooden bridge built across the railroad tracks joining east Willmar with Homewood Park/Sperryville.

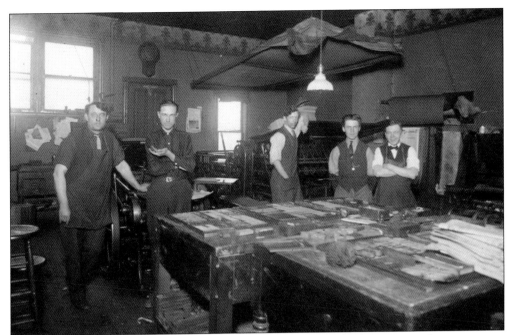

The newspaper was progressive and unapologetically reported on both positive and negative news in Willmar and throughout Kandiyohi County. With each passing decade, the paper remained the voice of the community. This 1915 photograph shows five *Willmar Tribune* employees standing in the printing room.

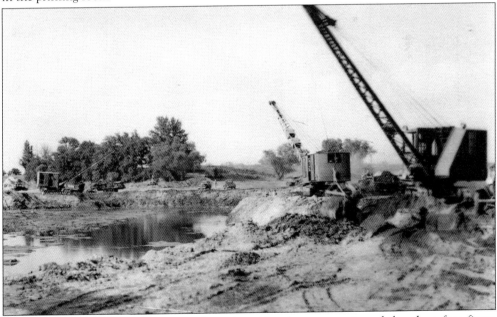

Some ideas to better the future are championed by the community, while others face fierce opposition. This photograph shows steam shovels digging a trench in an effort to connect several Willmar area lakes. The Willmar Chain of Lakes Project moved forward, but when enough people objected, the project was scrapped. This photograph was taken near the Willmar State Hospital on March 23, 1957.

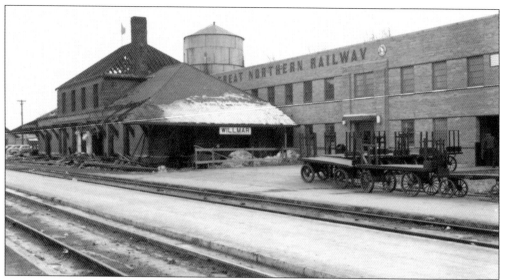

Out with the old and in with the new is the mantra of progressive thinkers. In 1948, when this photograph was taken, the newly constructed Willmar depot looms against the older depot, built in 1892, as it is being destroyed. More changes were to come when the Great Northern Railway merged with the Burlington, the Northern Pacific, and the Spokane Railways, creating the largest railway in the nation. The brickwork spelling out "Great Northern Railway" across the top of the depot would soon be covered by a Burlington Northern sign.

The Human Side was filmed primarily at the Willmar State Hospital. Willmar played host to its first motion picture premiere when the film debuted at the City Auditorium to a packed house on July 11, 1957. The film was made to help individuals see firsthand how they could serve mental health hospitals in their community. The cast of 123 hospital staff and volunteers, along with two paid actors, portrayed patients so well that Dr. Dale Cameron, director of medical services of the Minnesota Department of Public Welfare, had to be assured that releases from actual patients were not necessary. The film won the American Psychiatric Association's Silver Award. This photograph of the filming was taken in March 1957.

Swedish ambassador Gunnar Jarring visited the Victor Lawson Library on the second floor of the *Willmar Tribune* building on January 29, 1949. Lawson was the longtime publisher of the *Willmar Tribune*, an author, and a local historian. It was said that the ambassador was much impressed with the six rooms of the library, including the Swedish Room, which housed Swedish literature and other items of interest. Pictured along with Ambassador Jarring is the Swedish consul general in Minneapolis, Gustaaf Peterson, who holds Lawson's decoration from the King of Sweden after being made a knight of the Royal Order of Vasa.

In 1980, Litchfield Avenue was under construction as much-needed improvements were being made. The downtown redevelopment project involved new streets, sidewalks, city heat, and landscaping. Downtown Willmar officially reopened in 1982.

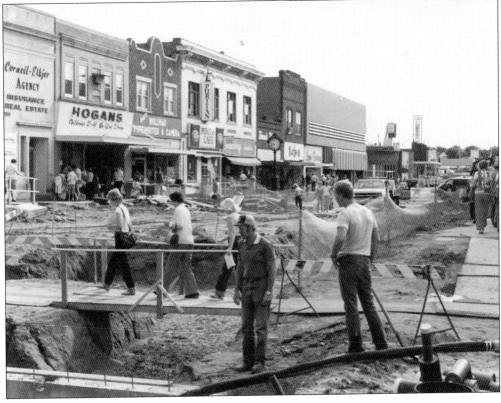

DISCOVER THOUSANDS OF LOCAL HISTORY BOOKS FEATURING MILLIONS OF VINTAGE IMAGES

Arcadia Publishing, the leading local history publisher in the United States, is committed to making history accessible and meaningful through publishing books that celebrate and preserve the heritage of America's people and places.

Find more books like this at
www.arcadiapublishing.com

Search for your hometown history, your old stomping grounds, and even your favorite sports team.

Consistent with our mission to preserve history on a local level, this book was printed in South Carolina on American-made paper and manufactured entirely in the United States. Products carrying the accredited Forest Stewardship Council (FSC) label are printed on 100 percent FSC-certified paper.

MADE IN THE
USA